VILLAGES OF
MID CHESHIRE
THROUGH TIME
Paul Hurley

AMBERLEY PUBLISHING

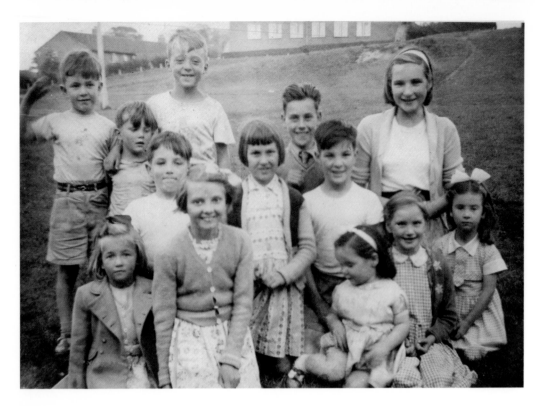

Photograph of a group of children in Farm Road, Weaverham, taken in 1958. The estate was completed in the early 1950s.

About the Author

Paul Hurley is a freelance writer and published author who has a novel, newspaper, magazine and book credits to his name. He lives in Winsford with his wife and has two sons and two daughters.

www.paul-hurley.co.uk
paul@hurleyp.freeserve.co.uk

First published 2009

Amberley Publishing Plc
Cirencester Road, Chalford,
Stroud, Gloucestershire, GL6 8PE

www.amberley-books.com

Copyright © Paul Hurley, 2009

The right of Paul Hurley to be identified as the
Author of this work has been asserted in accordance
with the Copyrights, Designs and Patents Act 1988.

ISBN 978 1 84868 682 3

British Library Cataloguing in Publication Data.
A catalogue record for this book is available from
the British Library.

Typeset in 9.5pt on 12pt Celeste.
Typesetting by Amberley Publishing.
Printed in the UK.

Introduction

The Vale Royal of England is the impressive title held by Mid Cheshire. The name was given to the area in the thirteenth century by Edward I when he named the new *Vallis Regalis* Vale Royal. Edward laid the foundation stone for Vale Royal Abbey in 1277 and then returned for the consecration in 1283. The biggest Cistercian abbey in the country, it was built near what is now Whitegate village. Many stories exist of the Abbots of Vale Royal and their tyrannical rule, the history of the abbey had many episodes of unpleasantness and disgrace leading to intermittent uprisings by the local people against the monks. Whitegate is named after the white stone gate to the abbey grounds.

At the Dissolution of the Monasteries the abbey and lands came into the hands of the Holford family of Holford Hall who, over the years, became joined by marriage to the Cholmondelay family of Vale Royal, later the Barons Delamere. In the late sixteenth and early seventeenth centuries an Elizabethan house was built on the site but replaced in 1833 by a new house designed by Edward Blore. A south wing was added in 1861 by John Douglas, the well-known Sandiway architect who went on to re-model Whitegate village and design some 500 buildings in Cheshire including the Eastgate Clock in Chester. There is now little evidence of the great abbey and the house has been turned into a golf club.

This book records in photographs the villages of Mid Cheshire through the years; the inclusion of a village, however, depended on the availability of old photographs suitable for print. In the case of Weaverham I had the support of Mike Hornby, the chairman of the Weaverham History Society and one of the best that I have come across. Weaverham is not short of historical buildings and each one bears a blue metal plaque placed there by the society. Other people helped with knowledge and photographs and quite pleasant raids were carried out on village pubs in search of photographs to scan. I apologise if a few of the old photographs are below the quality that I would have liked but they were the only ones available and I wanted to include as many villages as possible.

Britain is full of pretty country villages, and Cheshire is sometimes overlooked, as it has a reputation as a wealthy county that is not overtly pretty in a Cotswold sort of way! That is a misconception, Cheshire has many villages and towns that can compare favourably with the likes of the Cotswolds and I have tried to show this, at least in the Vale Royal area.

Within these pages the reader can see just how little the villages have changed over the years and how many ancient buildings still exist to delight the visitor.

They say that the sense that we remember best is smell, and I remember from my youth the Mid Cheshire countryside and farms and the myriad of smells that emanate from them to assault the senses in a most pleasing manner, like the scents of wood smoke, cow sheds and wild flowers. Remembering old sights such as that of a Ferguson tractor at the end of the day, the driver's face illuminated by the little red light on the dashboard as the last load of sheaves is brought to the barn. December and threshing time when the stored sheaves would be broken down and the corn extracted in the threshing machine. Frost would decorate the trees and ice would fill the nearby canal, black and white cottages with lights shining from the small windows and smoke drifting lazily from the chimney, this is what villages mean to me. Things have to change but at the same time some things stand still and history is sometimes kind. Many Mid Cheshire villages have now been extended by the building of modern estates and those halcyon days of old have given way to busy roads that children once used as playgrounds.

I have intentionally omitted an index or list of villages, the reader is invited to find time, relax and browse their way from Moulton to Church Minshull via the villages of Mid Cheshire, stopping to enjoy the sights that were once to be seen and compare them with what is there now. I hope you enjoy reaching the book as I have enjoyed compiling it.

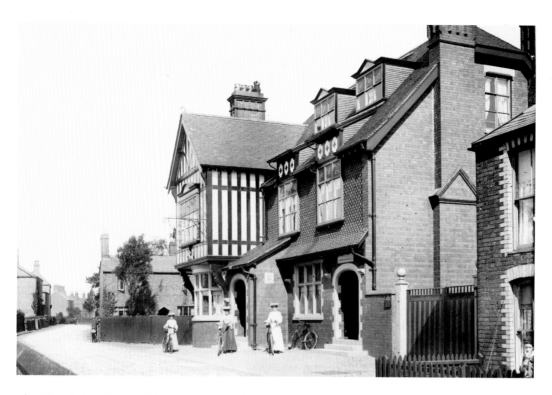

The Lion Public House Moulton, 1896 and 2009

Until 1894 Martha Lyon, married name Jackson, ran a grocer's shop and beerhouse on the site, prior to this her husband had operated the business. Being an entrepreneur, Martha had the present public house built and named it, appropriately, the Lion, with a subtle play on her maiden name. She remained as landlady until the pub was sold to Ind Coope's brewery in the early 1920s. Moulton housed mainly salt workers from the many Winsford salt works a short way off via the railway arches.

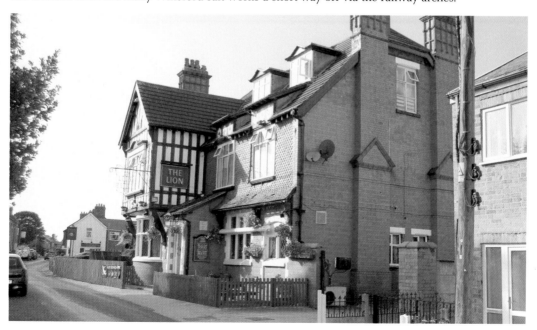

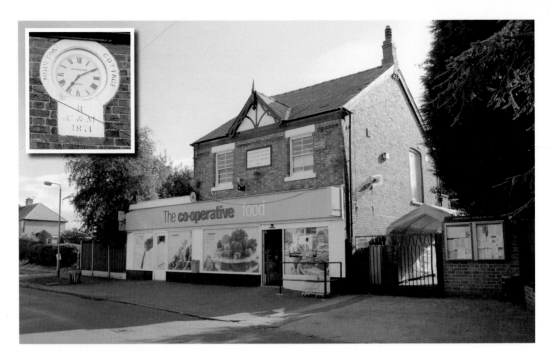

The Co-op, Moulton, 1920s and 2009

The Co-op in Moulton was opened in 1896 by the Winsford Co-operative Society to serve the needs of this growing community. The village is ancient, having been mentioned in the Domesday Book, but grew quickly in the 1800s to serve the salt industry. A very insular community then with a tremendous spirit, a cottage was built at the end of School Lane in 1871 with a clock on the wall to serve villagers who could not afford their own timepiece. Initially it housed a cobbler and clog maker's.

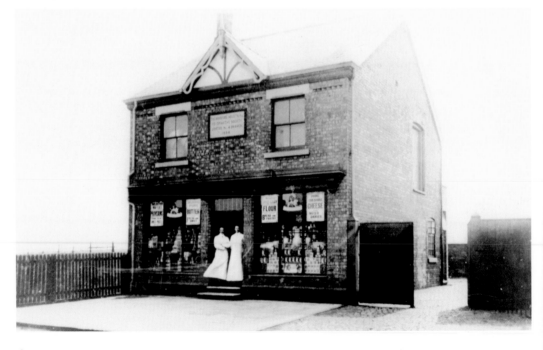

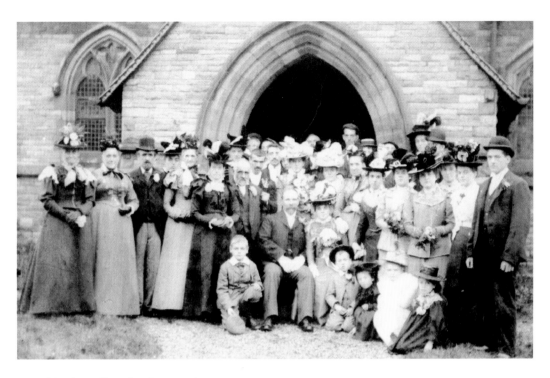

Moulton Church, 1890s and 2009

The foundation stone for St Stephen the Martyr's parish church was laid in 1876 and was consecrated the following year. It had been sponsored by the Revd France-Hayhurst of Bostock Hall. Here the Buckley family pose proudly for the camera. The village was thrust into the limelight in 2007 when grandmother Jane Felix-Browne married a scrap metal dealer from Jeddah in the Middle East. His name was Omar Ossama Bin Laden whose father is rather infamous!

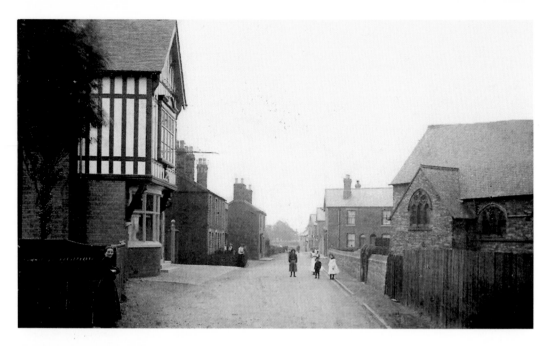

Moulton, 1896 and 2009

A view of the Lion pub from the opposite direction along Main Road with the rear of St Stephen's church on the right. Very little has changed over the years, possibly because the transformation of the village had taken place quite recently. In the 1960s the village grew again with new developments, and the population now stands at around 3,000. Church Street and Regent Street on the right had been built by salt works owners for their employees.

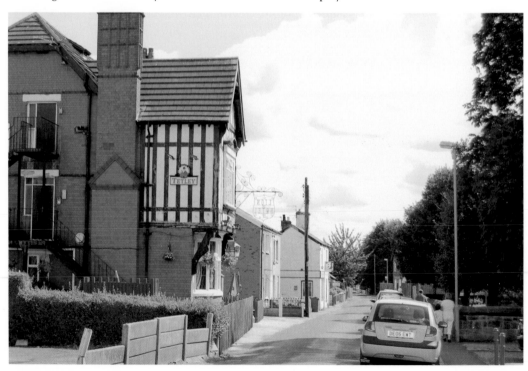

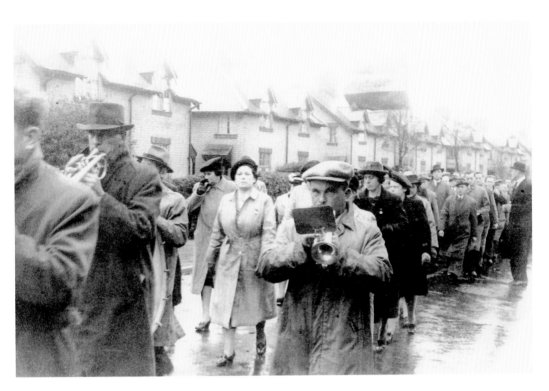

British Legion March, Main Road, Moulton, 1950s and 2009

This is a Remembrance Day parade by the Moulton British Legion in the early 1950s. Here the parade did not have far to march before reaching the war memorial. The houses in the background were built by the District Council between 1925 and 1928.

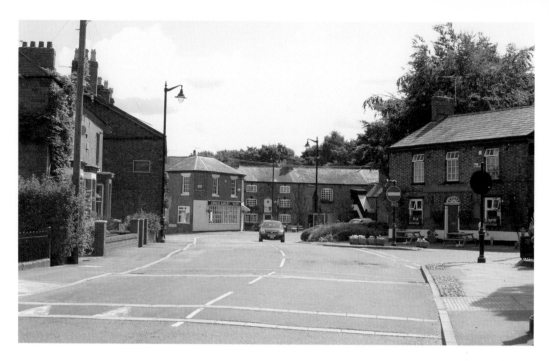

London Road, Davenham, 1900-1920 and 2009

This view taken from the Davenham roundabout side looks towards the Bulls Head in the distance and the Oddfellows on the right. The cottages after the Oddfellows have been demolished, but the view is remarkably unchanged. The Bulls Head has existed since 1764 and the Oddfellows since 1851. Once a very busy road, this has now been bypassed by the long fought for Davenham bypass.

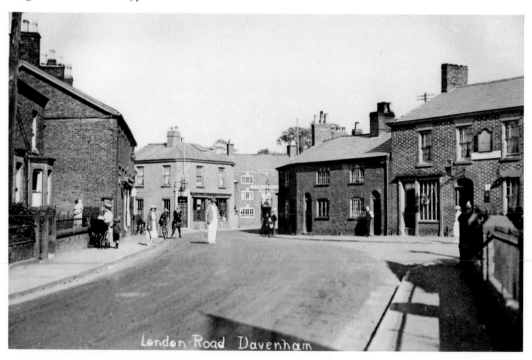

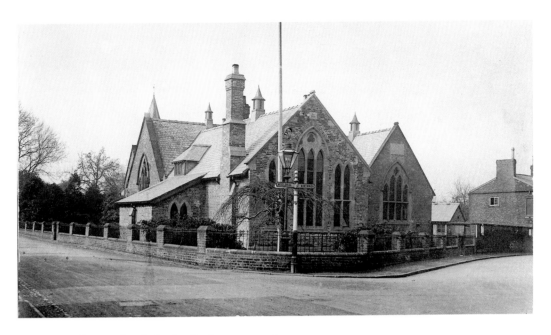

Davenham Schools in the Early 1900s and 2009

Once the main school for Davenham, in 1914 340 children could be accommodated and the average attendance was 223. Mathew Earlam was the master and Miss Mary Johnson the mistress, with Miss Louisa Horton as the infants' mistress. When a new school was built in Charles Avenue the old building was converted into flats.

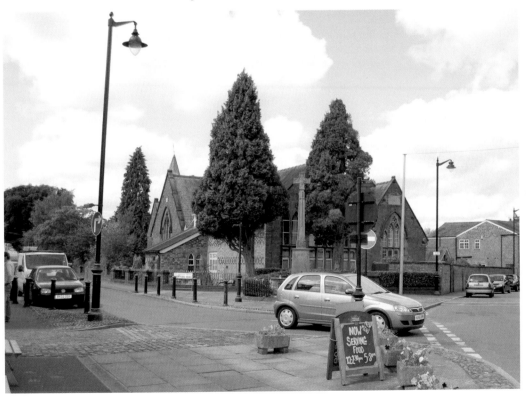

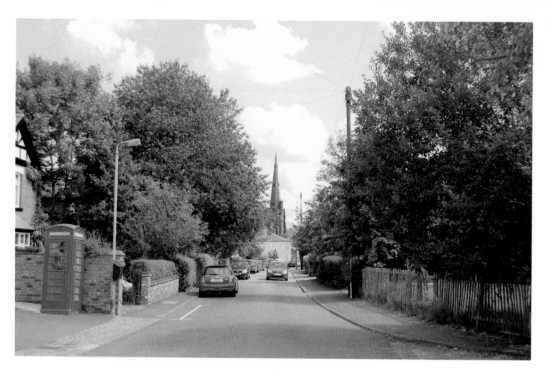

Church Street, Davenham, 1910-1920 and 2009

This street leads from the village centre into the countryside towards Bostock passing the parish church of St Wilfrid in the distance. The old photo, taken around the time of the First World War, shows it as a quiet and peaceful road, and apart from many parked cars this is still a quiet area. The houses on the left have now been hidden by a verdant vista of green beauty, perhaps due to the different seasons chosen to take the photographs. Paula Radcliffe, M.B.E., was born in Davenham.

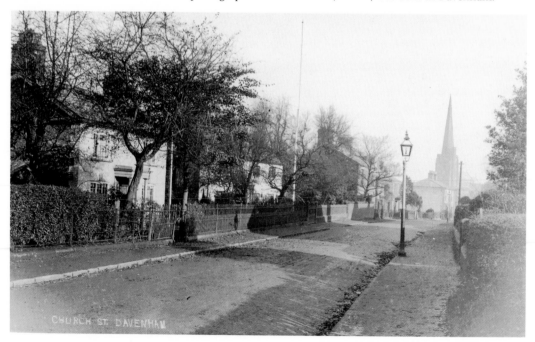

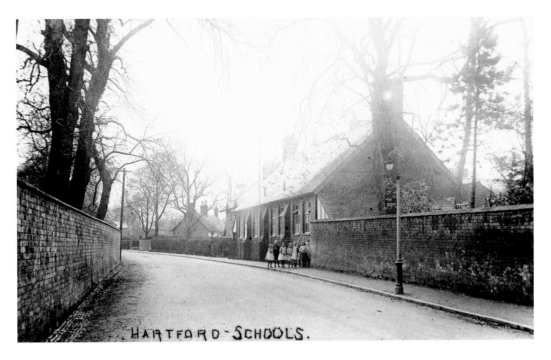

Hartford Schools, 1900-1915 and 2009

This was the main school building in Hartford built in 1833, and outside seven girls line up, five in pinafore dresses, to watch the photographer at work. The building now houses the Hartford Old School House Day Nursery. A more modern primary school is situated in Riddings Lane.

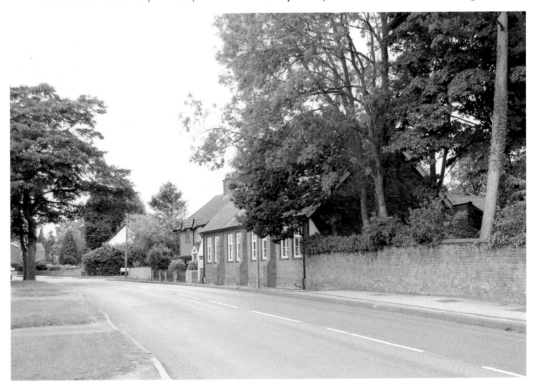

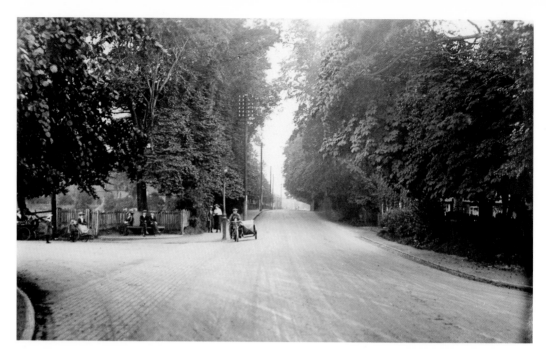

Cross Roads, Hartford, 1910 and 2009

I had to include this 1910 photograph with its period motorcycle and dress. There is a woman in a three-wheel invalid carriage and just at the side a woman with a child in a perambulator. Unfortunately in the new photograph road works are underway and the deadline for completion has been moved forward to finish on a date that passes the deadline for the book's submission. At the time of writing the locals are not at all happy with the situation.

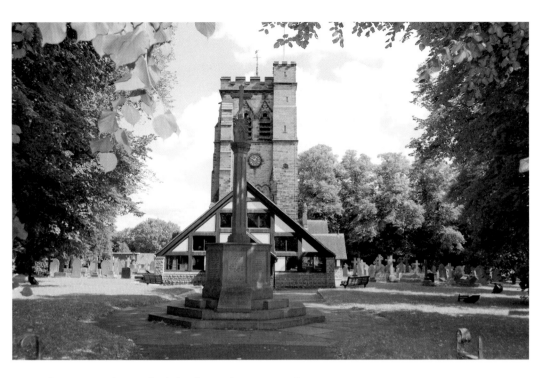

Chester Road, Hartford, in the early 1900s and 2009
A last look at this part of Chester Road as it passes the church towards Northwich. The church is now surrounded by foliage so a matching photograph cannot be taken from further back. Hartford had grown on the back of the LNER railway at Hartford station and the Cheshire Lines railway at Hartford and Greenbank (now just Greenbank). Large dwellings were built for merchants from Liverpool and Manchester who could live in leafy Cheshire away from the smoggy and crowded cities.

Hartford Church in the Early 1900s and 2009

A closer look at the Church of St John the Baptist at Hartford during the early part of the last century when it was quite new. A chapel of ease was built on the site in 1822 after the inhabitants had raised the cash to pay for it, and it was consecrated by the Bishop of Chester. The railways soon arrived bringing a population explosion and a new church was needed. In 1873 the current building was erected on the site, and then in 1887 the tower was built to commemorate Queen Victoria's golden jubilee.

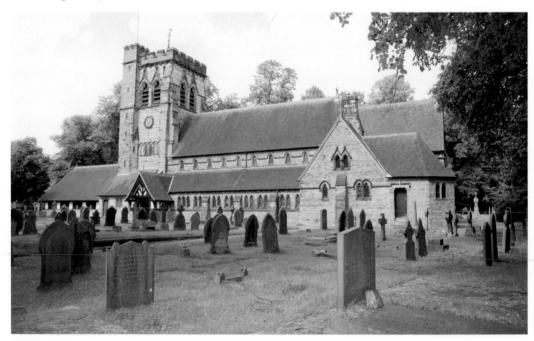

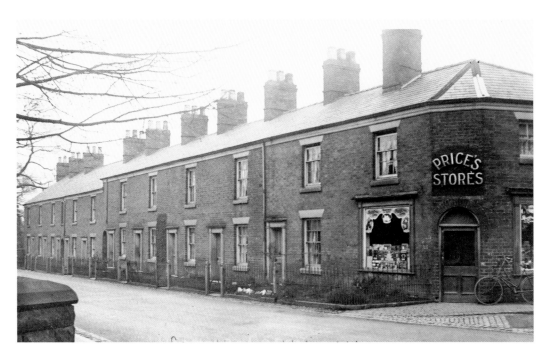

Green Villas, Hartford, 1900-1910 and 2009
Now a one-way street and situated across from Hartford church in The Green, not a lot has changed over the years. Price's general store has made way for an estate agent's and the lead flashing has given way to ridge tiles on the corner. The old pedal cycle is a very early one and dates back to the late 1800s when bicycling was a popular means of travel, especially for ladies.

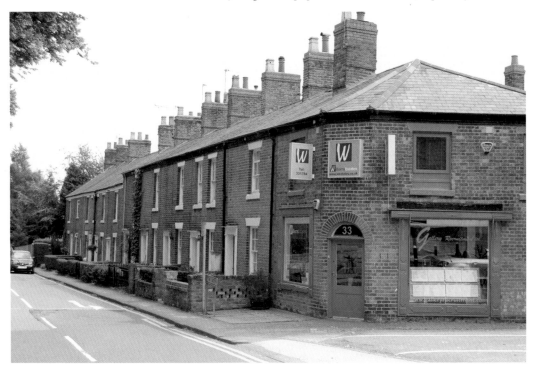

Chester Road, Hartford, 1920s and 2009

Another look at the village from further back with the Red Lion pub at the end on the right, the original Red Lion stood on the opposite side of the road. The present pub was then called the White Lion, and in 1857 Greenalls bought it. The original Red Lion closed and the licensee Isaac Wilson crossed the road, took over the White Lion and changed its name to the Red Lion. This was also the location of Hartford fire station and the pub outbuildings once housed the stables and the fire engine.

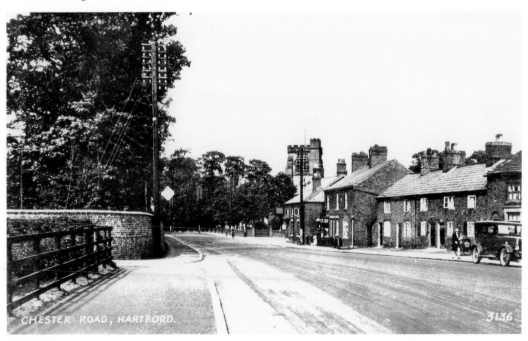

CHESTER ROAD, HARTFORD. 3136

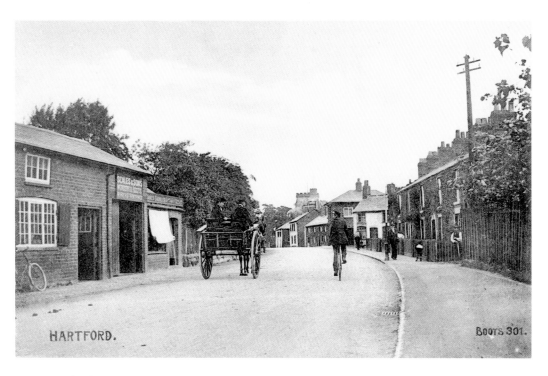

Hartford, 1915 and 2009

A last look at the village from even further back, a pony and trap with a postman on his bike make up the traffic on what is now a busy road into Northwich. The premises of Scales and Sons are on the left.

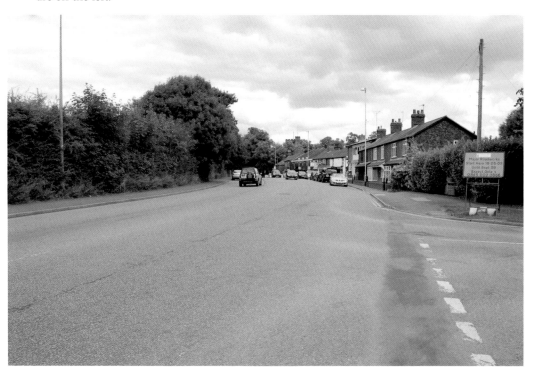

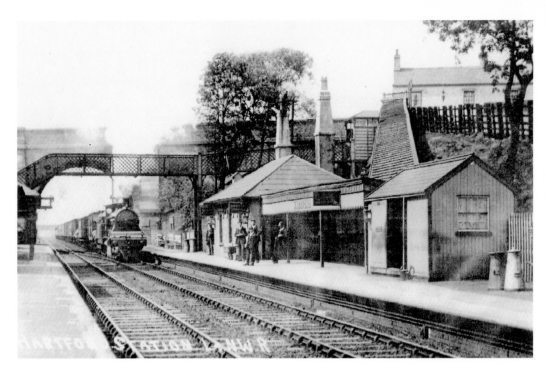

Hartford Station, 1906 and 2009

Built by the Grand Junction Railway, Hartford Station was opened in September 1837. Built in a deep cutting the steps to the main road were once covered, as can be seen in the old photograph from 1906. On the other side of the road is the Station Hotel, which had been a beerhouse built after the station as Hartford Station Inn. It was later called the Railway Inn, but in the old photograph it had become the Station Hotel. In 1971 it was renamed the Coachman.

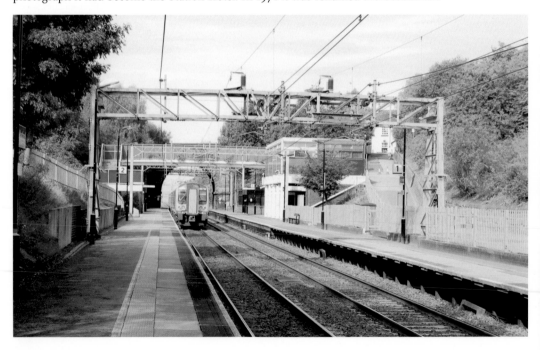

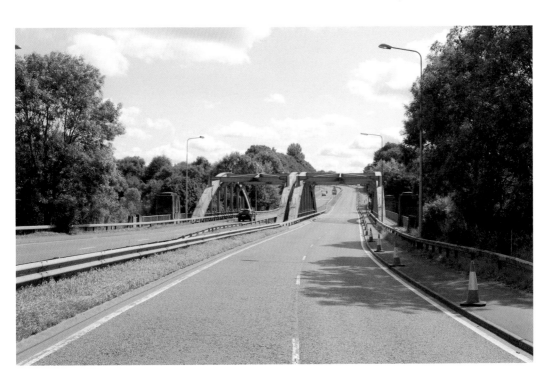

Hartford Bridge, 1900 and 2009

Northwich bypass or the A556 was built during the 1930s and 1950s; this was a period of building in a similar manner to that undertaken in Germany at the instigation of Adolf Hitler. He provided work for the many unemployed by building autobahns that ran straight and true through Germany. This impressive road, which included a cycle track, ran from Manchester to Chester and is now dual carriageway for a lot of the way.

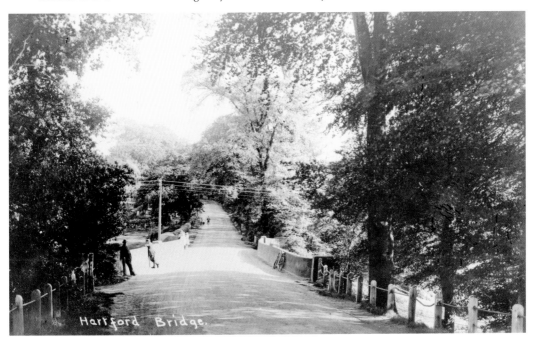

Hartford Bridge.

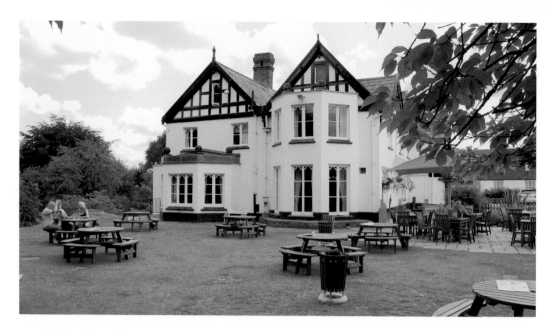

Hartford Hall, Undated and 2009

This old hall was built around the 1600s and was at the turn of the last century the home of Herbert Hatt-Cook, a well-known Northwich solicitor. According to my sadly now deceased friend Brian Curzon, Hatt-Cook had a daughter who married and emigrated to India. On their return she could be seen in the town dressed in a sari, not a usual sight in those days. A son had been born in India named Peter; Peter grew up to become a war hero in the RAF and later, as Group Captain Peter Townshend, planned to marry Princess Margaret. The rest, as they say, is history. In the 1960s the hall was converted into an up-market hotel and restaurant.

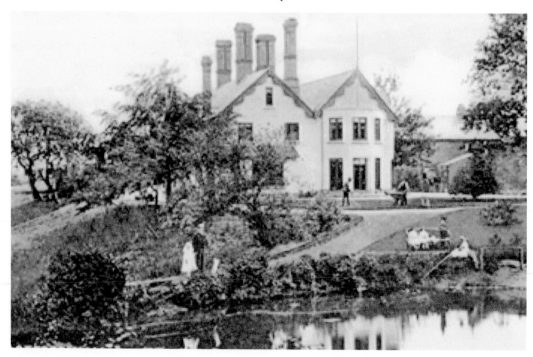

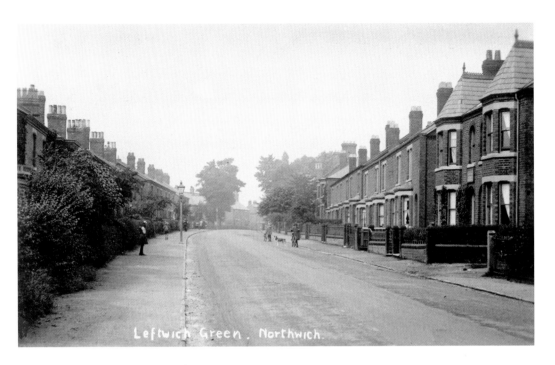

Leftwich Green . Northwich.

Leftwich Green, 1895 and 2009

This village situated between Northwich and Davenham was many years ago held by the Wilbraham family. An heiress of the family married Robert de Winnington whose son Richard assumed the local name and was the founder of the family of Leftwich. The old photograph taken at the turn of the century shows that little has changed over the years, once a busy road in and out of Northwich it has now been bypassed.

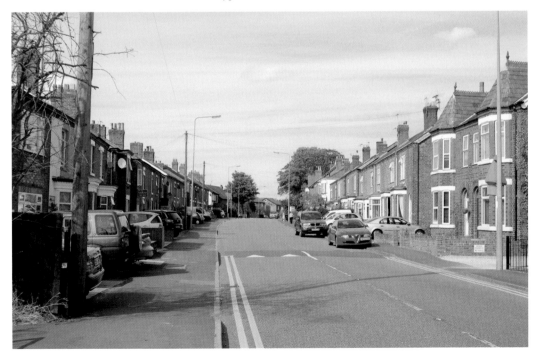

Beach Road, Hartford, 1910 and 2009

Thomas Horatio Marshall Esq. once lived at house near here called The Beach, 'a handsome residence' according to White's Directory of 1860. Beach Road is an unusual road name for land-locked Mid Cheshire. The Marshall families were members of Cheshire's landed gentry, local benefactors and salt mine proprietors. The name Marshall is now prevalent in the district.

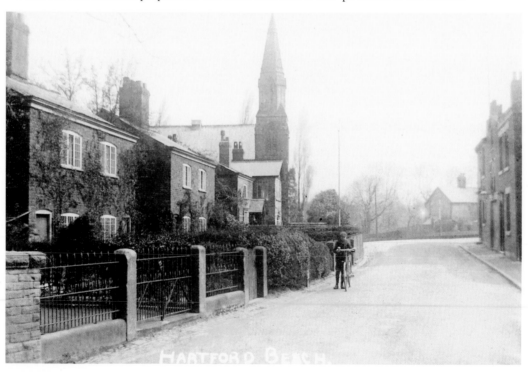

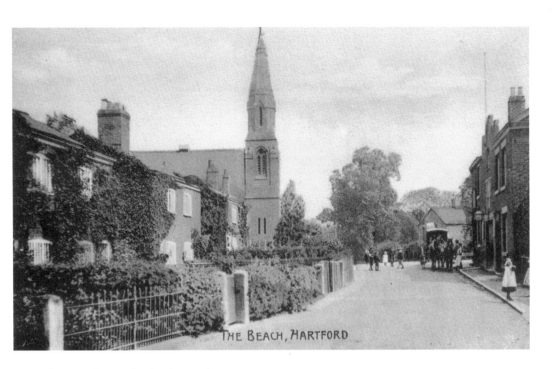

THE BEACH, HARTFORD

The Beach, Hartford, 1890 and 2009

Another look at what was the hamlet known as Hartford Beach looking towards Northwich. The church is a Methodist chapel, and was built in 1891; originally it was the building that is now the Methodist church hall nearby, built in 1833. The Sportsman pub can be seen on the right; it stood at the junction with Bradburn's Lane from 1841 until 1964, there was also an auction room here.

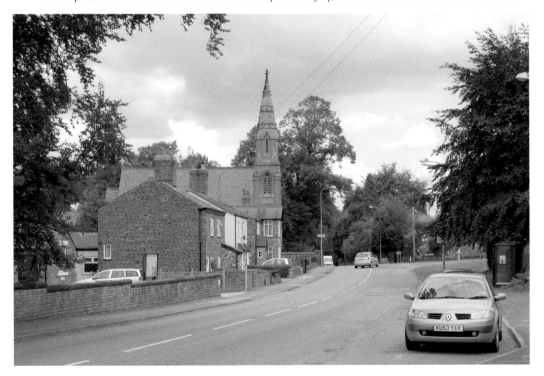

Old Cottage, Forest Street, Weaverham, 1920s and 2009

I make no apologies for including a few photographs of this cottage through the years; it is the home of Mr and Mrs Barrie Johnson who belong to the ninth generation of the Johnson family to live here. It is believed to have existed from between 1590 and 1630 and is on the first map of Weaverham dated 1660. Until 1870 the building housed four dwellings, and in that year it was converted to two. In the modern photograph the cottage is smaller and that will be explained in the following captions.

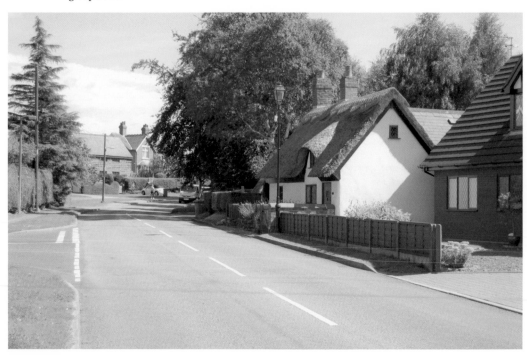

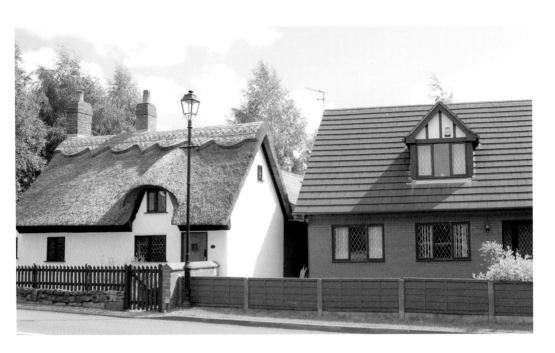

School Bank, Weaverham, 1900s and 2009

Back now to look at the cottage in the early part of the century as two ladies of the family somberly watch the photographer. You can see where the door was bricked up in 1870 and that the end door seen in the 1919 photograph led into the garden. In the modern photograph the cottage is shorter and land has been sold at the side to build a modern bungalow.

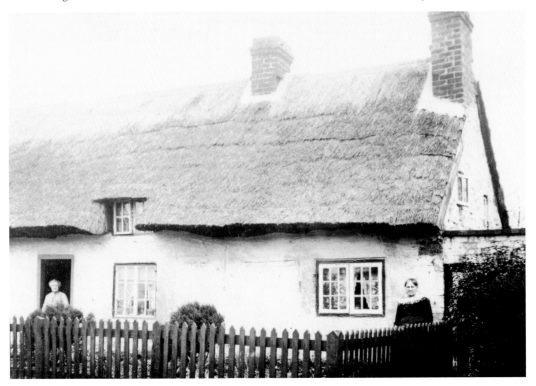

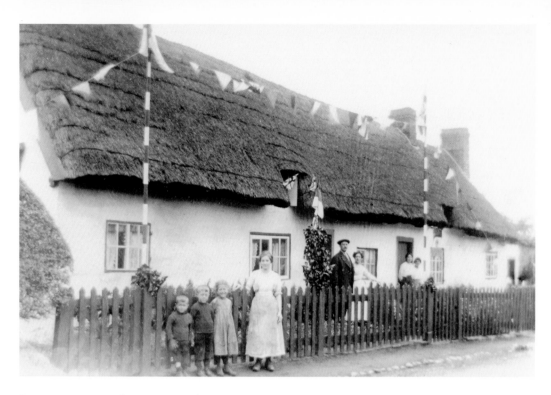

Peace Day, Weaverham, 1919 and 2009

This period photograph was taken on Peace Day in 1919 when the village celebrated what was then thought to be a lasting peace after the horrors of the First World War. In the photograph the extended Johnson family can be seen standing proudly beneath the bunting. Little did they know that there would not be a lasting peace and in the next conflagration the fabric of the cottage would suffer!

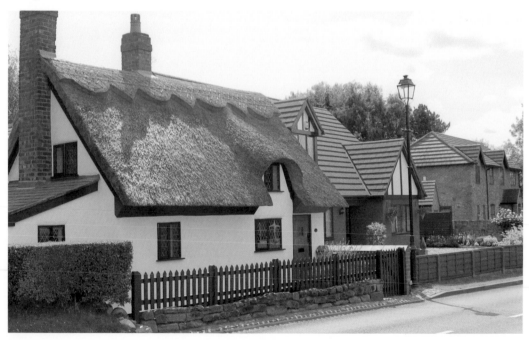

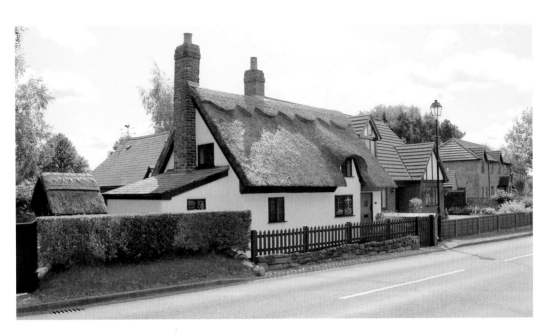

Weaverham Cottage, 1950s and 2009

The building is smaller now and the war is over. In the course of that war cousins lived in the cottage and took in children evacuated from Liverpool. The children managed to set fire to the thatched roof causing damage and then the Germans made it worse! They were aiming to blow up the railway viaduct at Dutton in 1940 when a landmine was inadvertently dropped on Nook Farm nearby, in the area that now houses the roundabout on the Weaverham Bypass. The end of the cottage was so badly damaged that it had to be demolished. Hence the sad building in the old photograph which had to be refurbished, rebuilt and extended at the rear by Mr Johnson. The very pretty cottage in the modern photographs is the result.

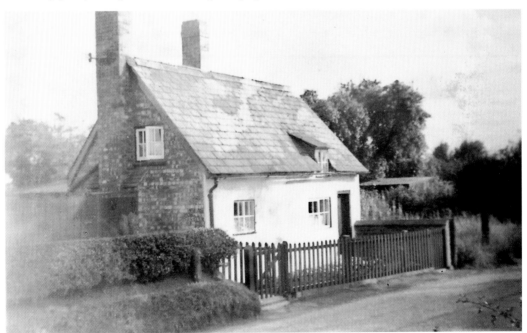

Weaverham Free Grammar School, 1905 and 2009

Just past the cottage in Forest Street is the old grammar school building, now a dwelling house. It is believed to date from 1638 and was once a courthouse. It was damaged in the Civil War and was a grammar school for hundreds of years, catering for the children of farmers in the area. It closed as a school in 1916, the last headmaster being John Trickett. A bit further on is a house that was once Weaverham Police Station.

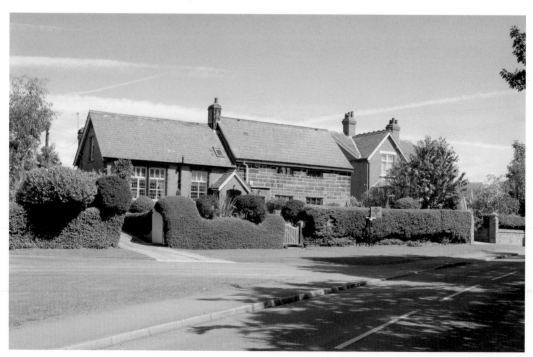

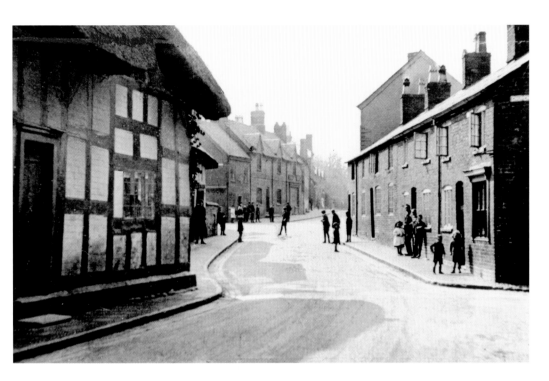

High Street, 1900 and 2009

In this, the first of the photographs of Weaverham High Street, we look into the old village from the Northwich direction and people walk around in the roadway. In the 2009 photograph the row of cottages on the right has gone leaving open land to the Wheatsheaf pub. Other than this, there is little in the way of change over the intervening hundred plus years.

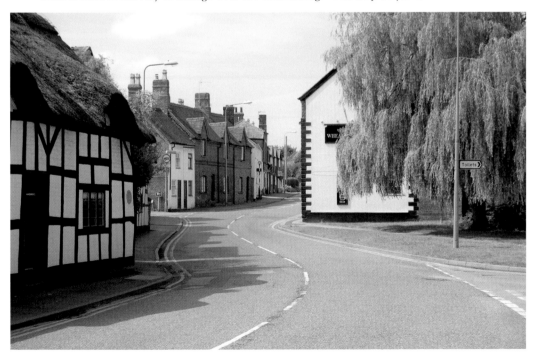

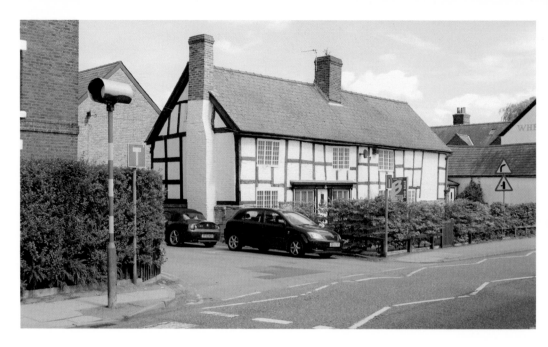

Weaverham Fire, 1950s and 2009

The old photograph of the fire was given to me some time ago because one of the children shown is me! I don't know which one, but I was there watching the firemen fighting the fire in the thatched roof. The building was next door to the Wheatsheaf and housed a cabinet maker's business, Mr J. Burns being the proprietor, and it is now two houses. The building on the extreme left is 14-16 High Street, now also two houses, it was once the Rifleman pub.

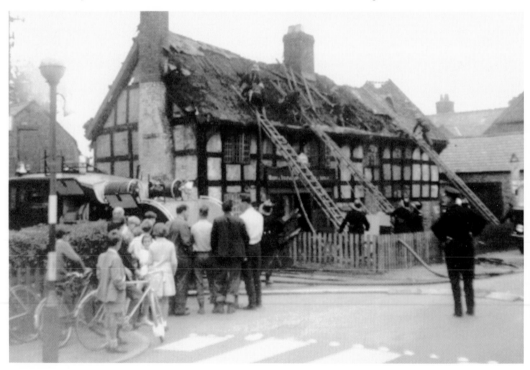

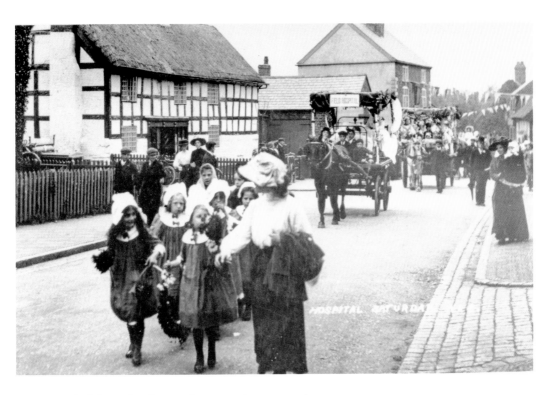

Hospital Saturday Procession, 1910 to 1920 and 2009

Another look at the old black and white building, the old photograph will have been taken in the early 1900s when the building housed William Phipps, painter and plumber. The procession is in aid of Northwich Infirmary and is entitled Hospital Saturday. This dates the photograph from before 1927 when it became known as the Weaverham Rose Festival, later the Rose Fête. What a pretty picture the modern one is with the gleaming white paint and exposed beams.

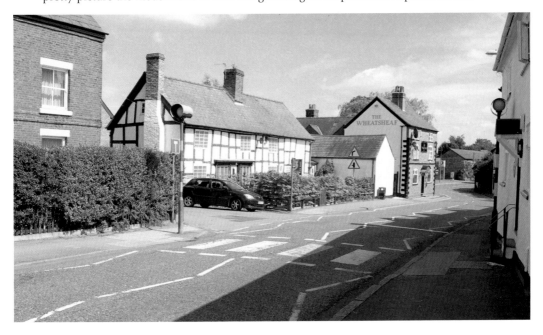

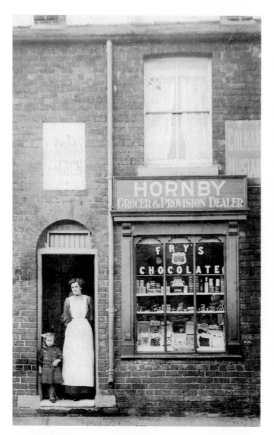

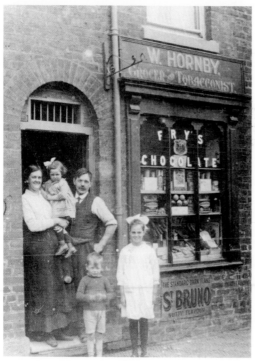

Grandma Hornby in the 1920s and 2009
The chairman of the Weaverham Historical
Society is Mike Hornby. Mike's family has
lived in the village for generations, and the
lady in the photograph is his grandmother.
The shop was situated at No. 32 High Street
and owned by Bill Hornby; by 1928 they had
relocated to a larger shop on the other side of
the High Street at No. 21.

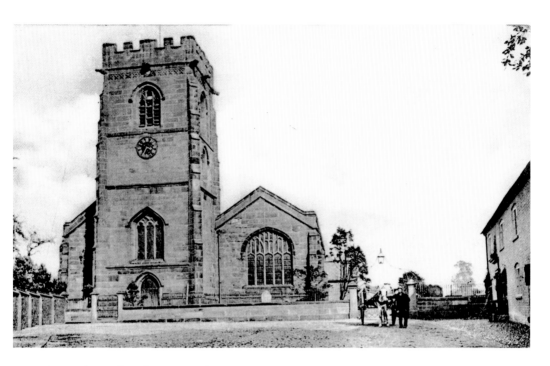

Weaverham Church, 1903 and 2009

The parish church of St Mary the Virgin is situated at the end of Church Street and dates back to the fifteenth and sixteenth centuries. The building on the right in the old photograph is the Ring o' Bells pub, as it was named in the early 1800s. It then became Church Stile and Church Gates before reverting back to the Ring o' Bells. In 1924 the licence was removed and a new Ring o' Bells built in the village. The old building was demolished to make way for the car park.

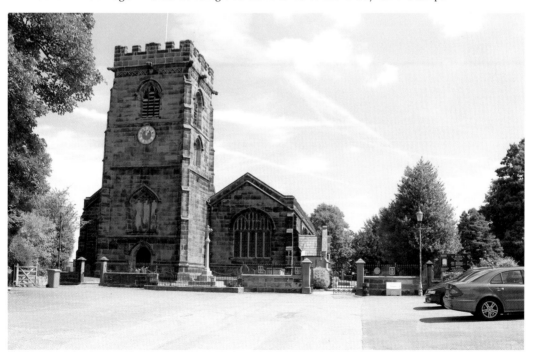

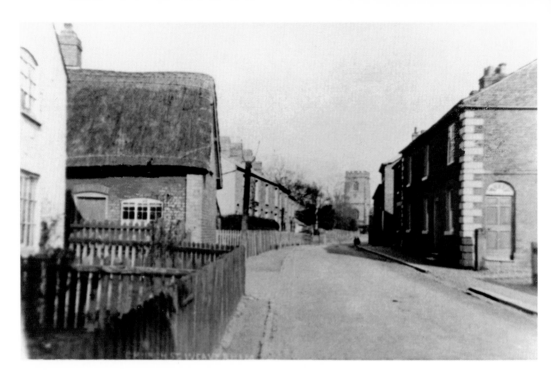

Raintub Cottage, Undated and 2009

Located in Church Street, Raintub cottage dates from around the time of Henry VIII. When under renovation in the 1980s a wall painting was discovered on the wattle and daub wall beneath layers of plaster. It depicted the branches of a yew tree, which will have been done for both decoration and to fend off evil spirits, as the yew was indigestible and sometimes fatal if eaten. It was also considered effective against demons.

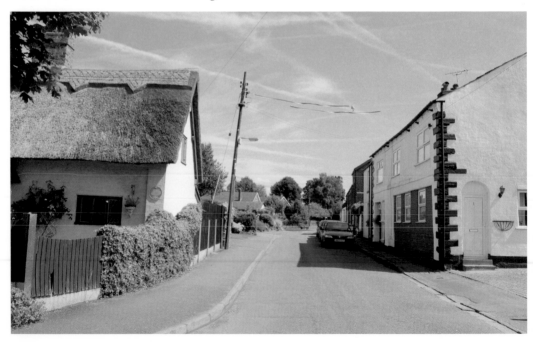

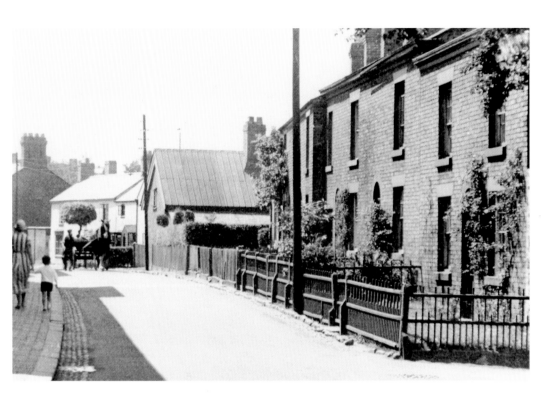

Church Street, 1920s and 2009

Another view of Raintub cottage, this time from the opposite direction. In the old photograph the cottage has a corrugated iron roof. As a child in Weaverham I remember that the old lady who lived in the cottage would sell groceries from the kitchen door when the shop over the road was closed. There is a coffin hole in the half loft ceiling as a coffin would be too large to bring down the narrow staircase.

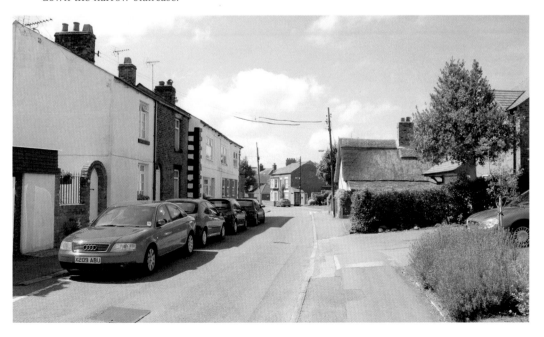

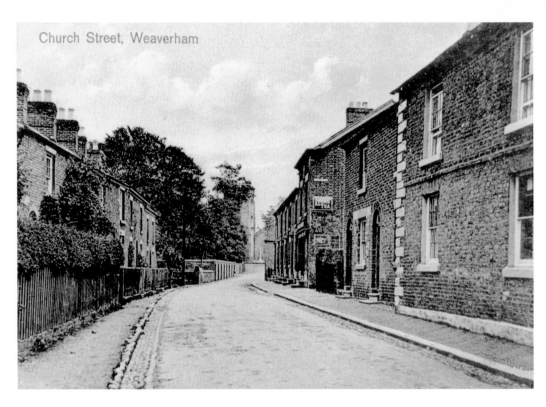

Church Street, Weaverham

Church Street, 1900s and 2009
A last look at Church Street, looking towards the church with the now demolished terraced cottages on the right; these cottages have been replaced with modern houses. The vicarage wall can be seen on the left and is at the junction with Well Lane.

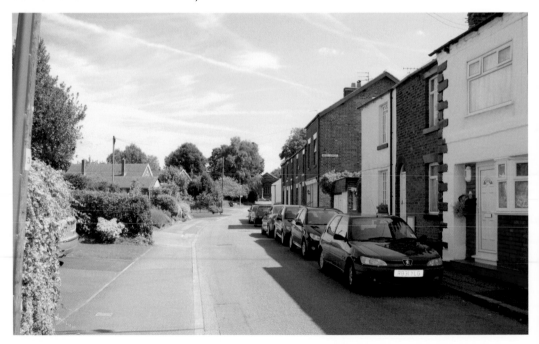

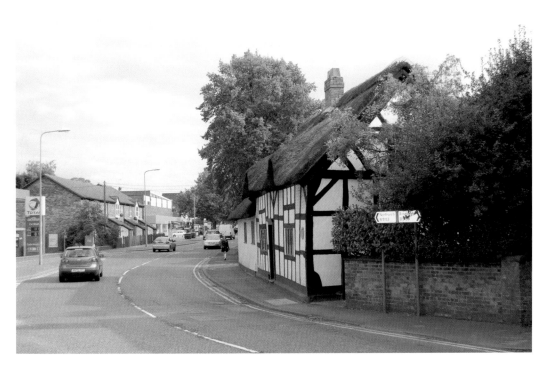

Northwich Road, 1890 and 2009

The main road through Weaverham before the coming of the bypass in the 1990s, and the view is back towards Northwich with the ancient Poplar Cottage on the right. This is an excellent example of domestic Tudor architecture, having been built in the fifteenth century. There is a 'birth chamber', a small room on the lower floor. Tradition has it that if a baby is carried upstairs after birth it will continue to go up in life!

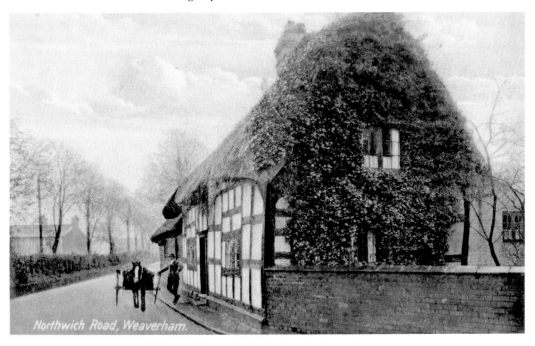

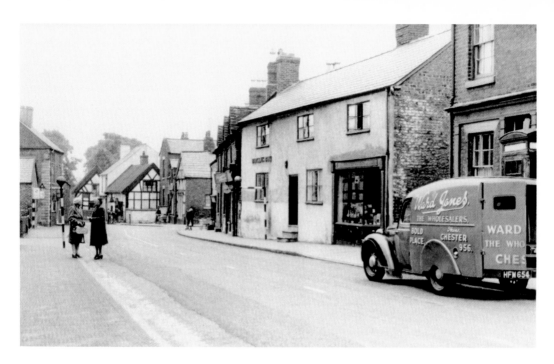

Weaverham High Street, 1950s and 2009

This photograph is filled with 1950s period charm, the ladies chat quite comfortably on the road and the road signs near the Wheatsheaf are black and white and filled with cat's eyes! Chapels Wine Bar on the right is a shop with a delivery van. The Belisha beacons outside Barclays Bank stand alone with no zigzags or black and white crossing, and the 2009 photograph shows that the shop next to the bank has gone.

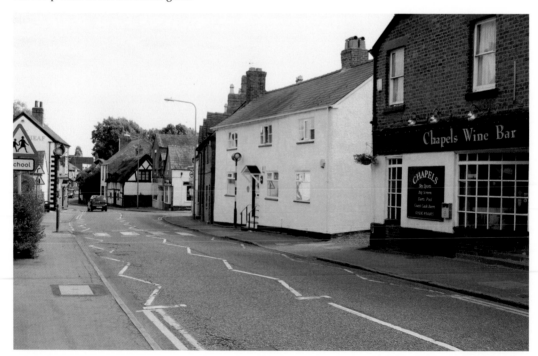

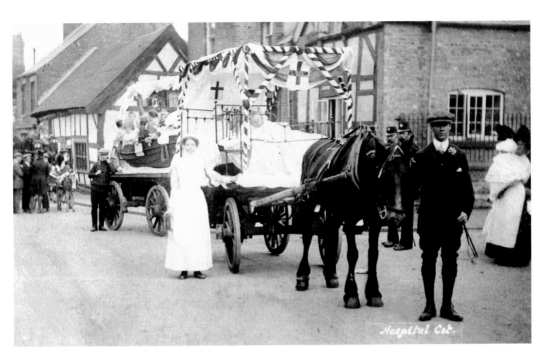

Hospital Festival, 1915 to 1920 and 2009

Another look at the area taken somewhat after the last one, the building at the Forest Street junction has now gone and railings have been erected. The first procession float depicts children in beds with a red cross behind them, the second, children in a rowing boat whilst two policemen in their shako helmets look on — one of these is possibly local bobby Sgt Ellwood. In the modern photograph big changes have taken place, and the old Star Inn is now two shops.

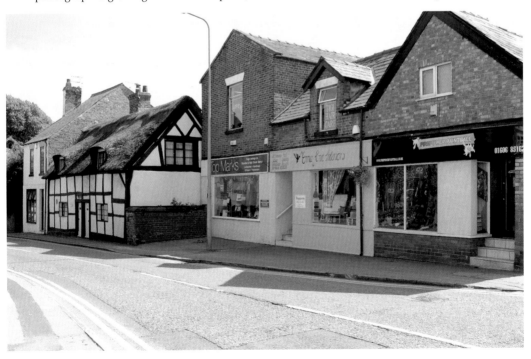

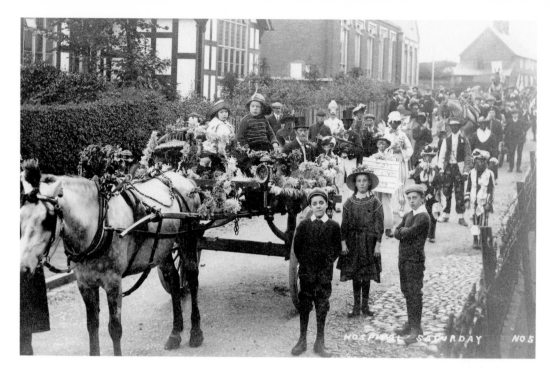

Forest Street, 1912 and 2009

Another look at the Hospital Saturday Procession, this time in Forest Street. The banner carried by the lad with the penny whistle seems to say 'The Tom Wilkinson Band'. The black and white building is the Barrymore Institute built on the site of an old cottage in 1907. The procession left from the Hanging Gate, paraded around the village and returned there for festivities, games and a pint or two!

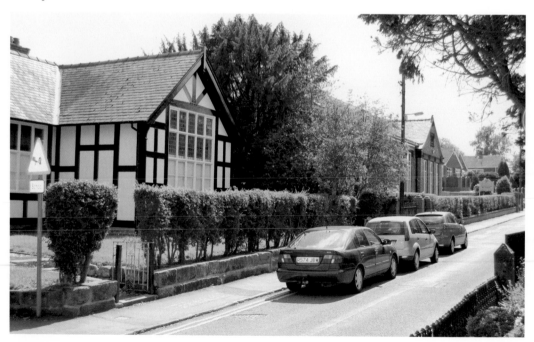

The Star Inn in the 1900s and 2009

The building on the right was the pub known as the Star Inn; it had been a pub since the 1700s. In 1911 it was sold to W. C. Buckley and opened as a clog maker and later a shoe and clothes shop. As the Star Inn it was the meeting place for the Weaverham Virgins' Club who on occasions became a little rowdy. Don't get the wrong idea here. They acquired that name from the Church of St Mary the Virgin to which they belonged, not from their abstinence from the pleasures of the flesh!

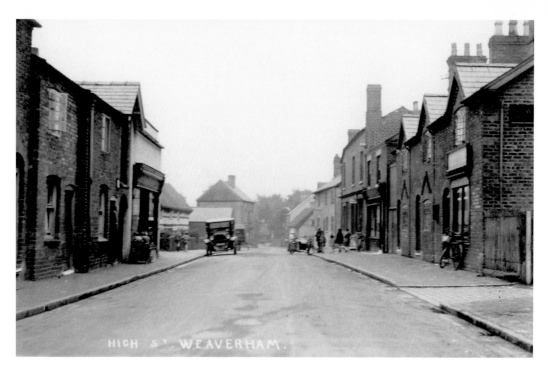

Weaverham High Street, 1910 to 1920 and 2009
Travelling backwards and forwards through time we have reached around the time of the First World War. The traffic consists of a petrol van, a horse van and a motorcycle and sidecar. Building-wise, there is very little change over the years.

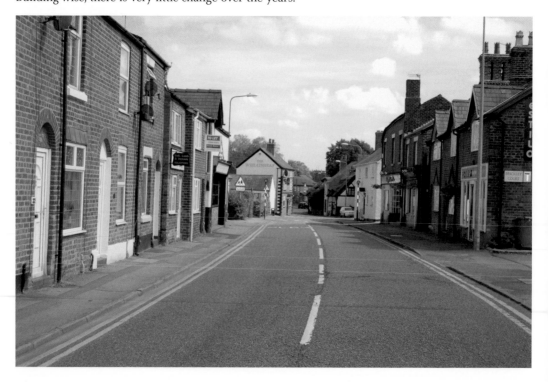

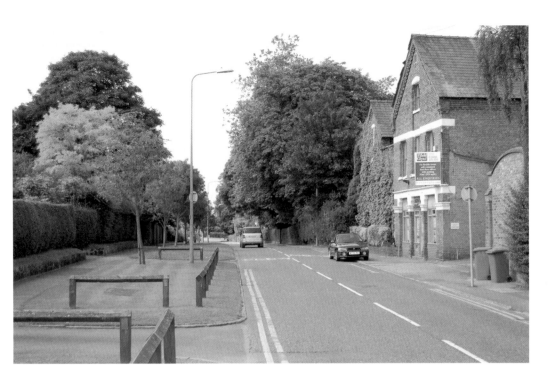

Weaverham High Street, 1900 and 2009

The large house and shop on the right was, during the 1800s, the business of Mr Benjamin and Mr William Burgess who traded as Burgess Brothers. A long standing company, who at the time traded in saddlery, drapery and furniture, under different family members it went on to become the well-known Northwich company, Burgess Bros (Agricultural Engineers) Ltd.

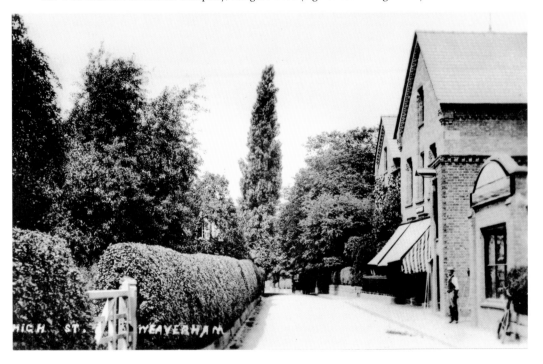

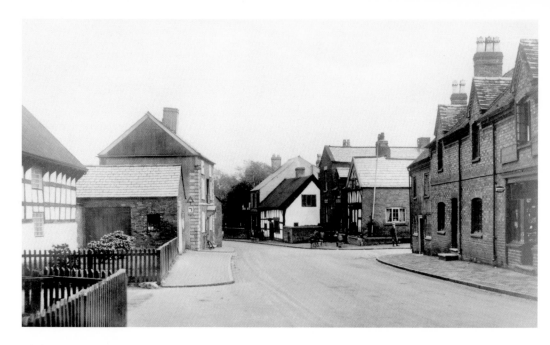

High Street, Weaverham, 1930s and 2009

Another look at Weaverham village and the old Wheatsheaf pub, which dates back to 1822 as a pub and probably further back to the 1700s. A very popular pub through the years in which the village elders ruminated over glasses of ale in the Knowledge Room, a bar room at the front of the building. One notable elder was 'Sergeant' George Allen who went to the first war with the local territorials as a sergeant and retained the title for the rest of his long life. Note the very early left turn sign.

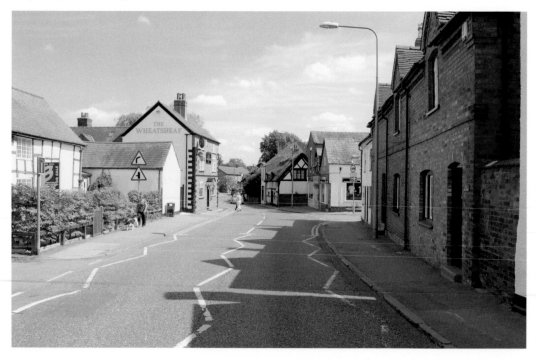

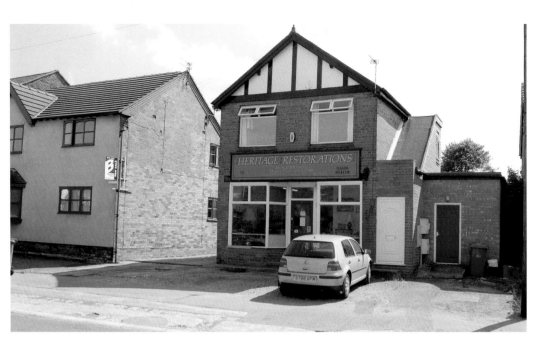

Buckley's Shop, 1950s and 2009

John Buckley had this shop in Wallerscote Road and in the early 1950s branched out as an electrical retailer. Televisions had started to appear and he took advantage of this, but it would perhaps have been advisable to keep the new TV the right way up in its box as the valves were very delicate! Businesses in these post-war days made a living by having a finger in many pies; Buckley's also sold petrol and clothes.

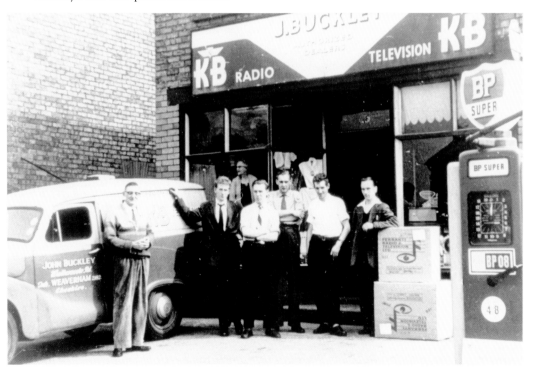

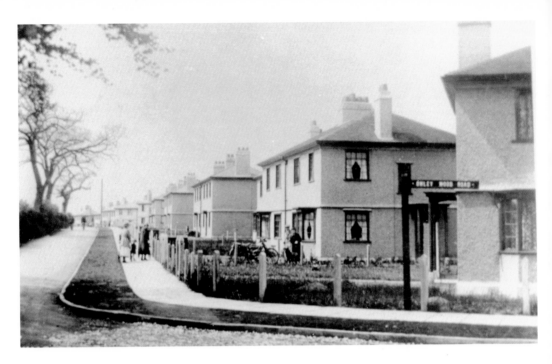

Wallerscote Road, 1935 and 2009

Until the 1920s Weaverham was a rural community of some 1,000 people, and then the ICI built the first of the estates for their workers in the village. Known as the Owley Wood estate, these houses were built of light-coloured brick but, quite unusually, each house had a concrete floor upstairs. Northwich Rural District Council were also busy building houses in the area and then after the war the building of council and private estates greatly extended the village.

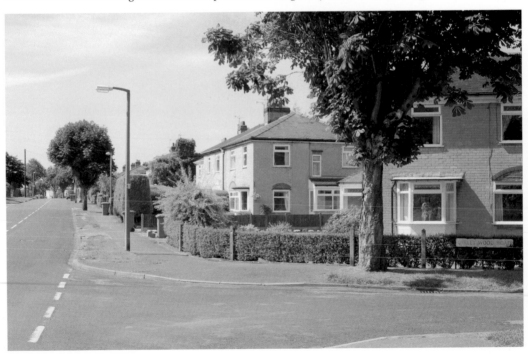

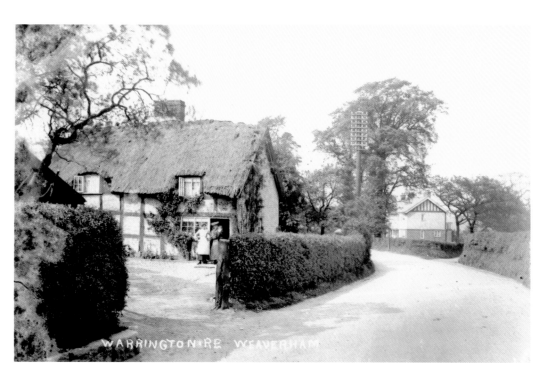

Inglenook Café, Early 1900s and 2009
This old cottage stood on Sandy Lane just past the Hanging Gate and almost opposite the entrance to Shady Brook Lane. Mainwaring's cottage, which became the Inglenook Café, was a popular haunt of cyclists in the 1920s.

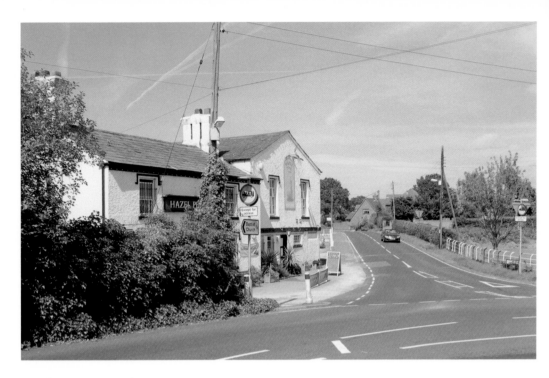

Hazel Pear, 2009 and 1900

Over the years the name Railway Hotel went out of favour and most pubs of that name saw it changed — a bit of snobbery perhaps, who knows? But the Acton Bridge Railway Hotel had to be renamed. One of the commonest pears in the area was the Hazel or *Hessle* Pear and there was an orchard of them at the rear of the pub, so in 1972 the pub's name was changed from the Railway Hotel to the Hazel Pear.

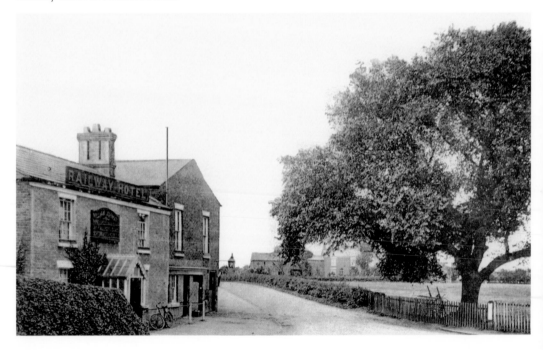

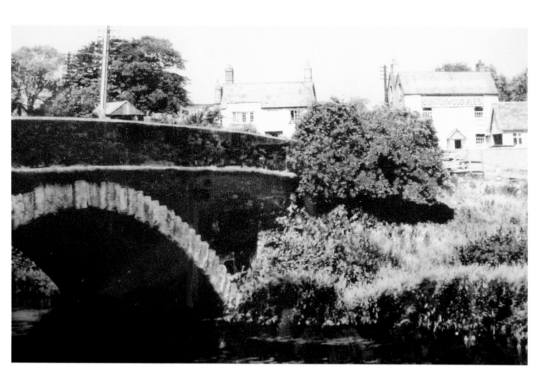

Old Acton Stone Bridge, 1895 and 2009

In 1730 a lock was constructed at Little Leigh to make the River Weaver navigable from Frodsham Bridge to Winsford. The stone bridge at Acton, as shown in the photograph, was the original river bridge. Eventually this was bypassed by a separate cut to carry shipping and a swing bridge installed. The stone bridge in the old photograph still carried the main road but was joined by the swing bridge.

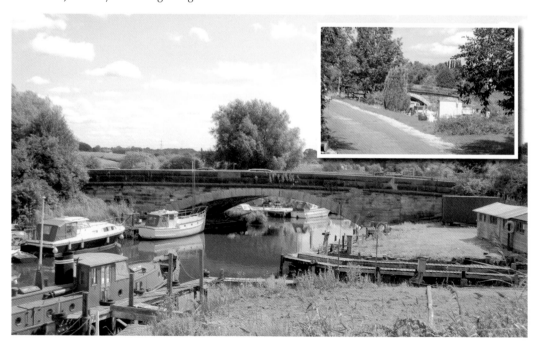

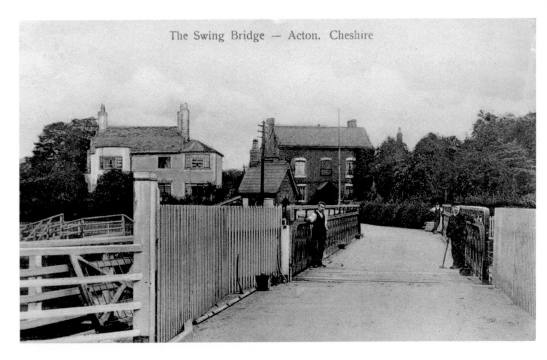

Acton Swing Bridge, 1895 and 2009

This is the original old swing bridge; the rail has been raised to protect horses and their riders. In the 2009 photograph the location of this bridge can be seen, much nearer to the Leigh Arms. In 1933 the new swing bridge was opened nearby, built in the same way as the Northwich town bridges, at this time the road was also re-aligned and the old stone bridge simply led to the small island now used as a mooring and boatyard.

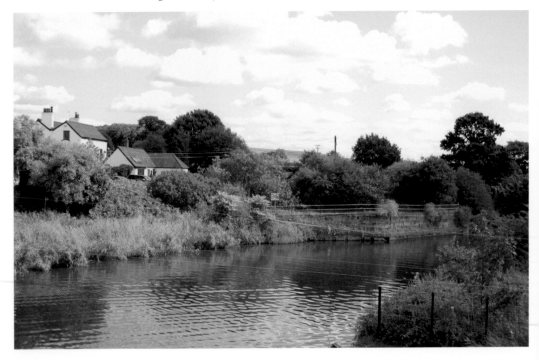

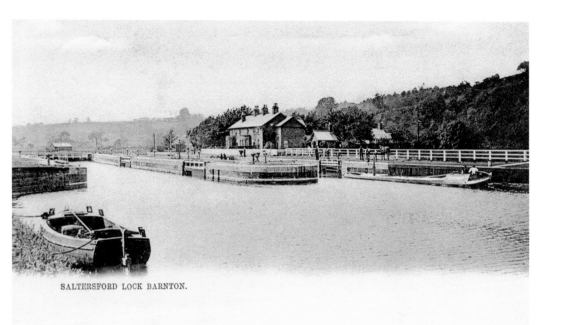

SALTERSFORD LOCK BARNTON.

Saltersford Lock, 2009 and 1800s

This large lock downstream from Acton towards Northwich has carried over the years a large number of coasters and salt flats. Now, however, it only serves the odd ocean-going ship, and the main traffic consists of pleasure boats carried from the canal by the Anderton Lift. The old photograph shows a well-loaded canal boat about to enter the lock as the horse stands patiently, enjoying the break perhaps! The lock keepers' cottages have large bay windows allowing the incumbents a good look along the river.

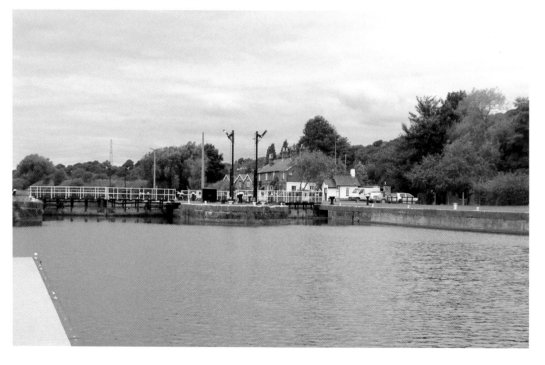

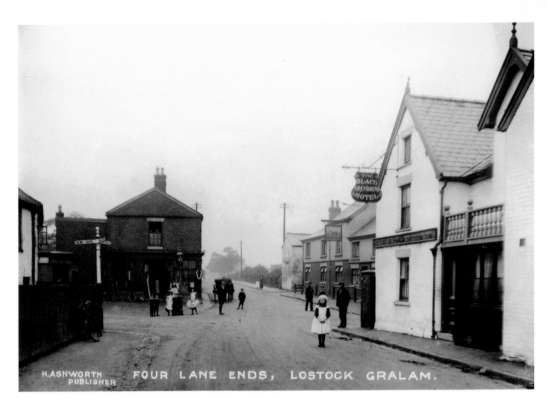

Four Lane Ends, Lostock Gralam, 1890s and 2009

In this atmospheric photograph the Black Greyhound pub can be seen on the right and across the junction is the old Slow and Easy, named, like a lot of pubs in the area, after a horse or, in this case, two horses! The pub had existed since 1763 but was demolished in 1937 when a new Slow and Easy was built set back from the road. The large building on the left has gone to allow road widening and the one shown in the modern picture, now a Chinese restaurant, was behind it.

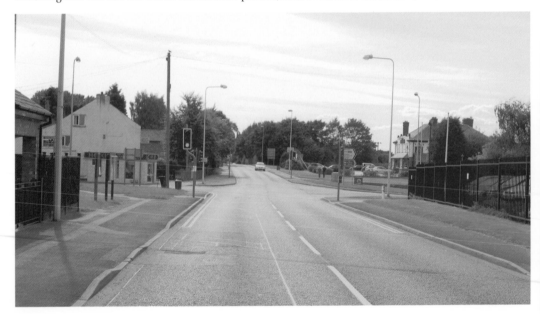

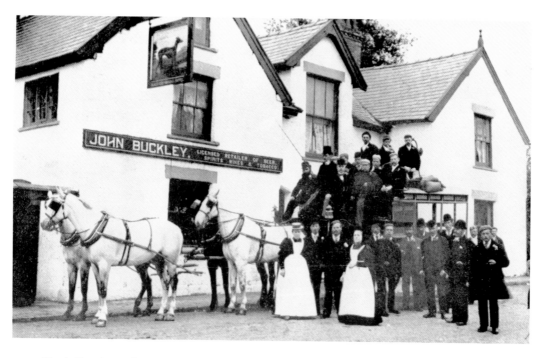

Black Greyhound, Lostock Gralam, 1895 and 2009

A look at the Black Greyhound from the opposite direction as a horse-drawn coach awaits passengers. The name of the licensee is John Buckley who held the licence from 1888 to 1900. Later the pub would be demolished, and the land is now a car sales premises. A new Black Greyhound was built in 1938 at the Wincham crossroads. It is this building that is in the 2009 photo; note the similarities in the old and new buildings.

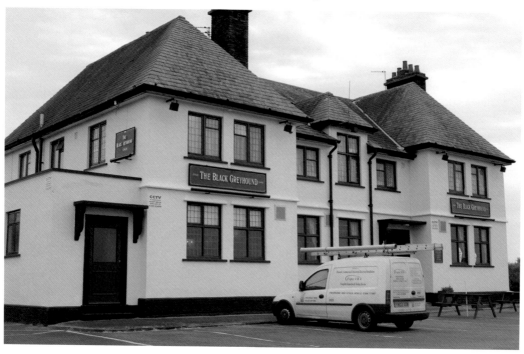

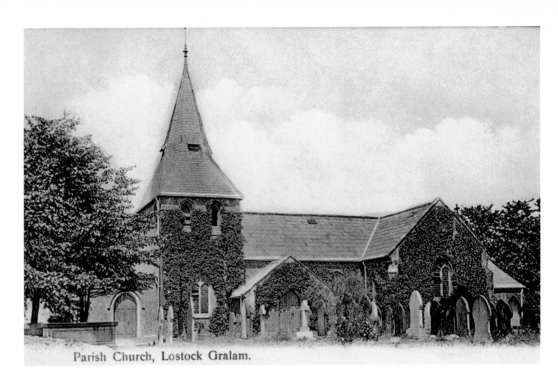

Parish Church, Lostock Gralam.

Lostock Church, Undated and 2009
St John the Evangelist at Lostock Gralam was built in 1845 to serve the villages of Lach Dennis, Birches, Hulse and Wincham.

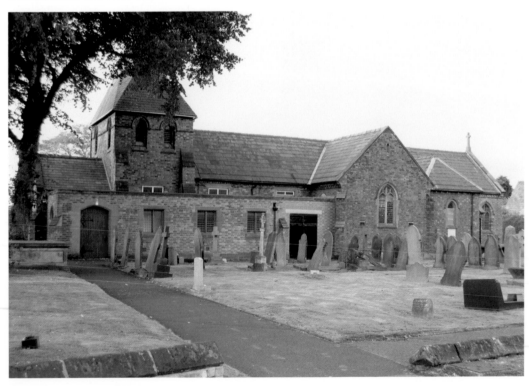

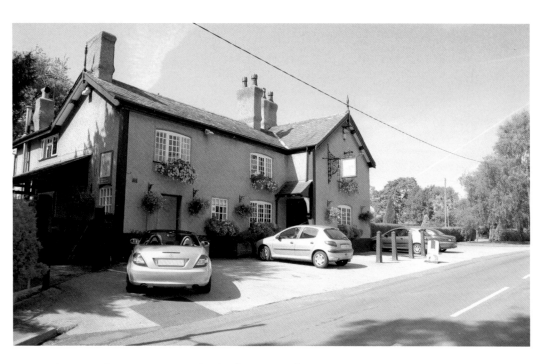

Spinner and Burgamot, Comberbach 2009 and 1900 to 1910

The first licensee Joseph Morris took over in 1770; it was formerly known as the Spinners Inn after one of J. H. Smith-Barry's race horses. In the early part of the last century the name was changed to the Spinner and Burgamot, Burgamot being another horse. The man in the old photograph taken in 1900 is the licensee whose rather flowery name was Albert Isaiah Coffin Lees — no wonder he looked miserable! He was tenant from 1898 to 1915.

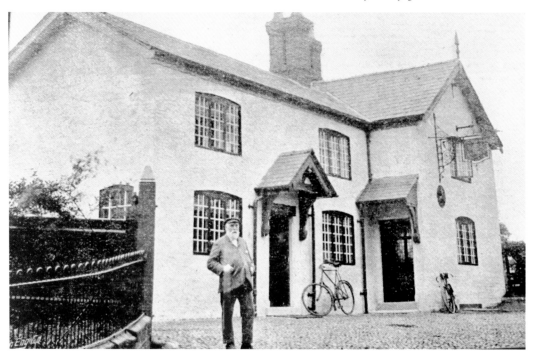

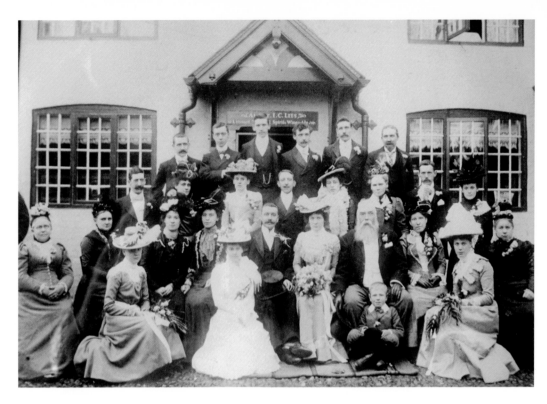

Spinner and Burgamot, 1900 to 1910 and 2009

A photograph of a wedding party posing outside the pub. It can be seen that the small window in the centre of the new photograph was once the door to the pub, and the present-day door was once a window.

Pickmere Lake, 2009 and Early 1900s

Pickmere Lake in Pickmere was for many years a holiday destination. In this 1900 photograph boats are for hire and cruises on the lake by steam boat may be enjoyed, as time passed this entertainment included a permanent fairground.

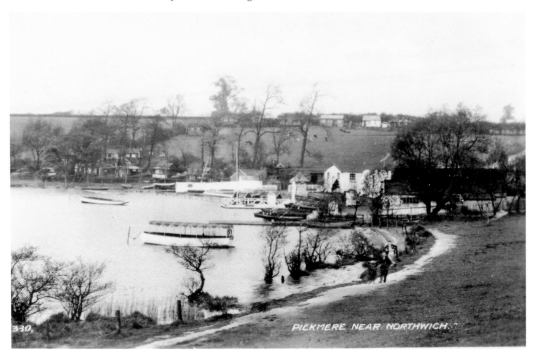

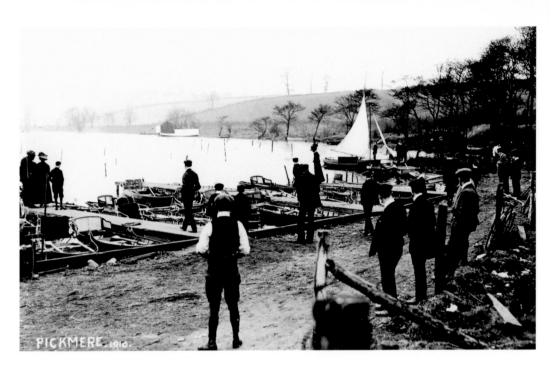

Pickmere Lake, 1910 and 2009

It's now 1910 and hire boats abound, having evolved through the years as social fashions dictated it is now simply a pretty lake with pleasant walks around its perimeter. There are also strategically placed picnic areas.

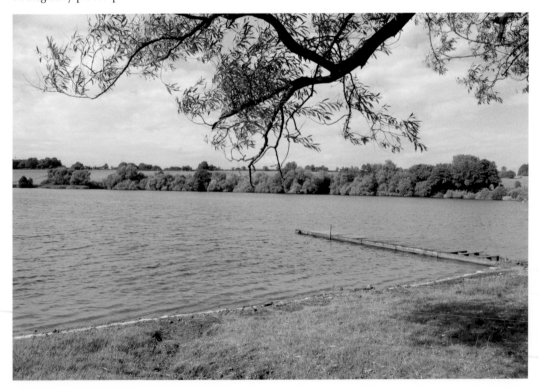

**Great Budworth,
1900s and 2009**
Now in the village proper, we see
just how little has changed over the
years and why the village is such a
favourite with period film makers.
This is Church Street looking
towards St Mary's and All Saints'
church. The oldest part of the church
is the Lady chapel, which dates back
to the fourteenth century. The rest of
the church can be dated back to the
fifteenth and sixteenth centuries.

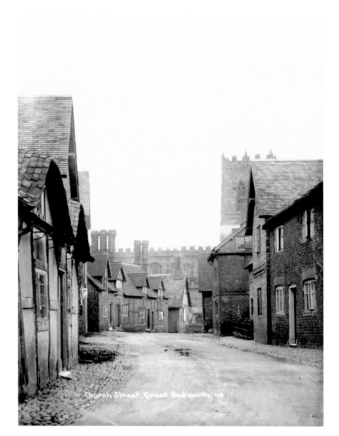

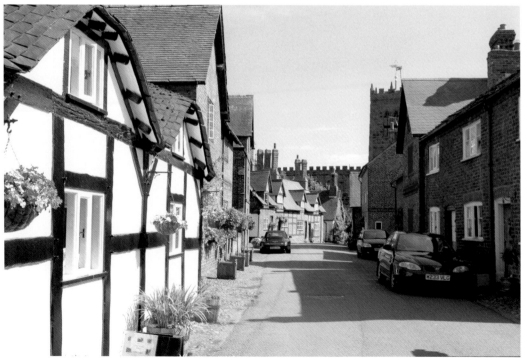

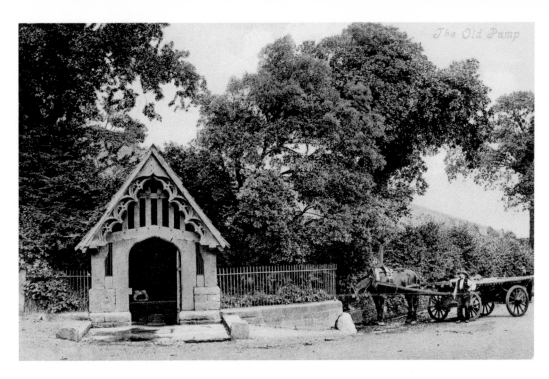

The Old Pump

Great Budworth Pump, 1906 and 2009

This well-known landmark was built in 1869 to cover the well which is the site of the old Great Budworth running pump, the only supply of water available to the village from 1869 to 1890. Then five pumps were installed and remained the source of water until a mains supply was piped to the village in 1936. The pump still provides running water that is favoured by amateur wine makers and brewers who wish to avoid the chlorinated tap water.

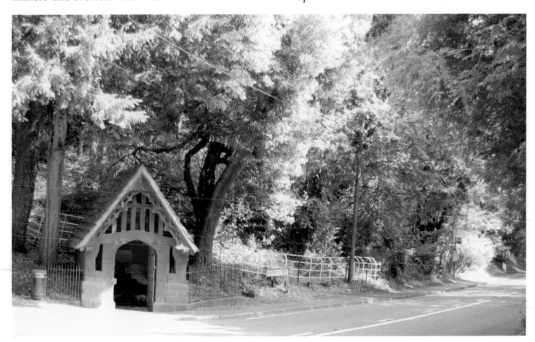

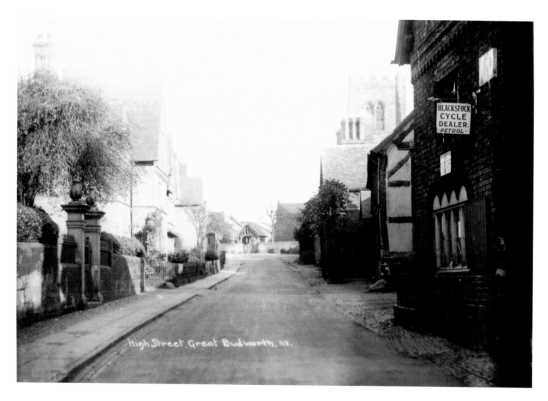

High Street Cycle Dealer, Early 1900s and 2009
Note the arched windows on the right. In the older photograph the premises of Blackstock's cycle dealer who also sold petrol to the early cars. This building also housed the post office.

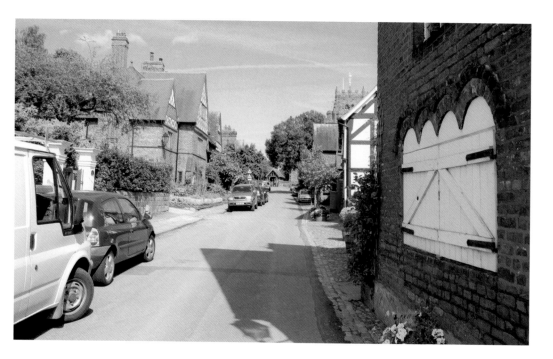

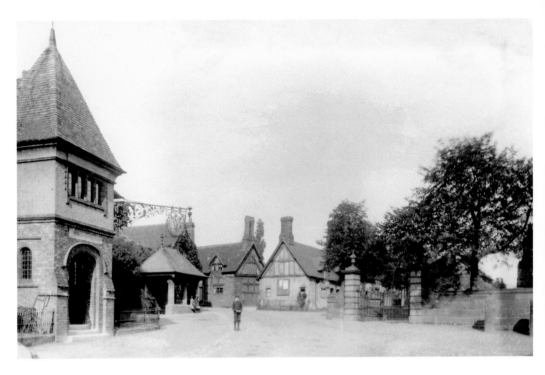

Great Budworth Stocks, 1910 and 2009

Most ancient villages had a set of stocks, usually, as in this case, near to the church. In Great Budworth the stocks are still there. They were in use until 1854 to calm the village scallywags and deter those from other villages. To sit strapped into them as rotten fruit is thrown at you is an effective deterrent — perhaps it might work nowadays!

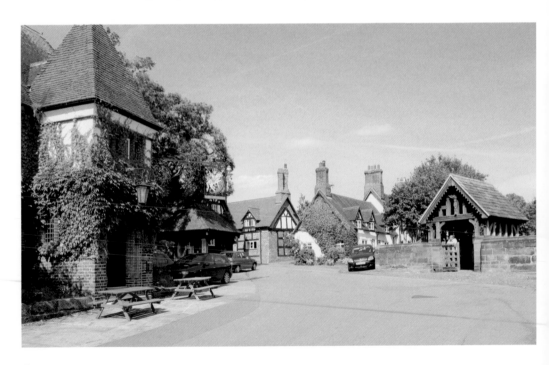

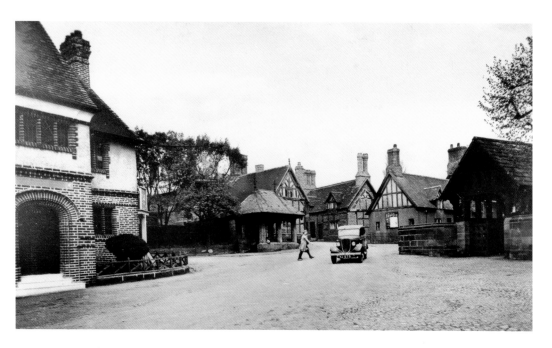

Great Budworth, George and Dragon, 1955 and 2009

Further up in the village centre showing the Lychgate to the church and the George and Dragon pub. After the forced closing of the lesser public houses in the village many years ago the George and Dragon is the only one remaining. It is now under new management and has been refurbished back into a typical village pub — but with excellent food! The old Ford saloon sits well in the centre of the 1955 photo.

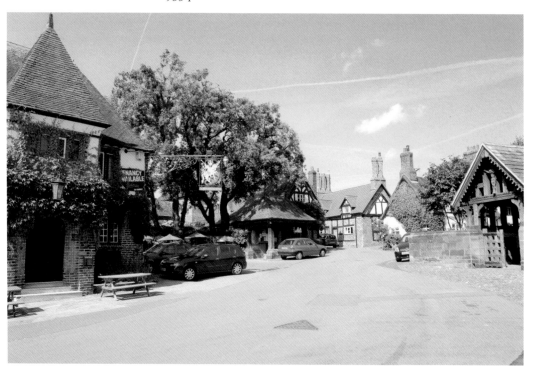

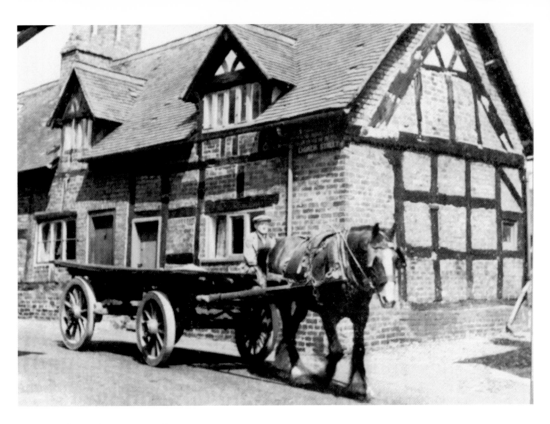

Great Budworth, Horse and Lorry

This evocative shot of a horse-drawn lorry in Church Street, another example of how little the village has changed; the house has been tastefully modernised but has retained its ancient façade. The old photograph is undated but will have been around the turn of the last century although such transport was used well into the 1950s with supports at each end to convert it into a haywain.

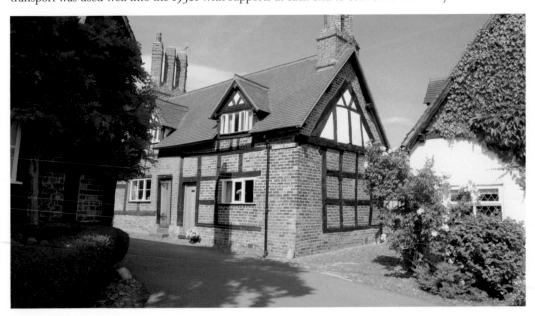

Antrobus Post Office, 1900 and 2009

This is a poor photograph but shows that little has changed in this small village and even the post office is still open, this is a quite unique situation as it closed in 2002! The local community then got together and appealed for it to remain open. As a result a community shop came into being, staffed solely with volunteers from the village. It is open for seven days every week and has gone from strength to strength; profits are used for the benefit of the community.

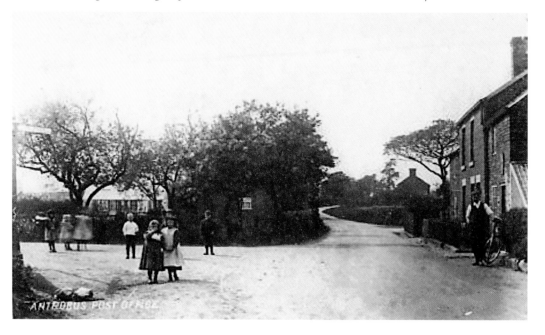

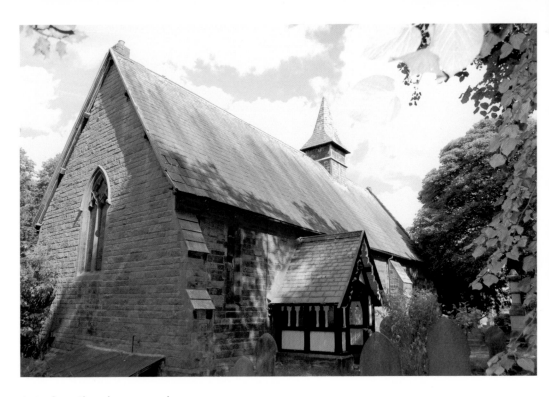

Antrobus Church, 1900 and 2009
St Mark's Church of England church was opened in 1848 to serve Antrobus and Seven Oaks, later taking in other villages.

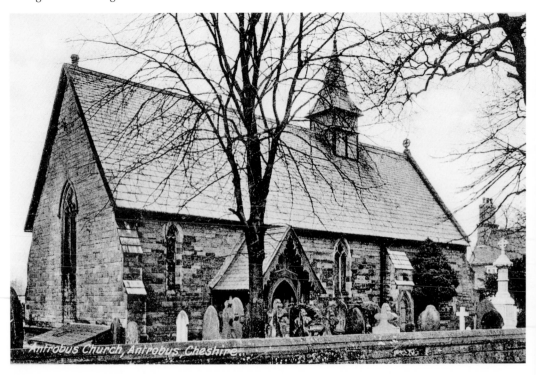

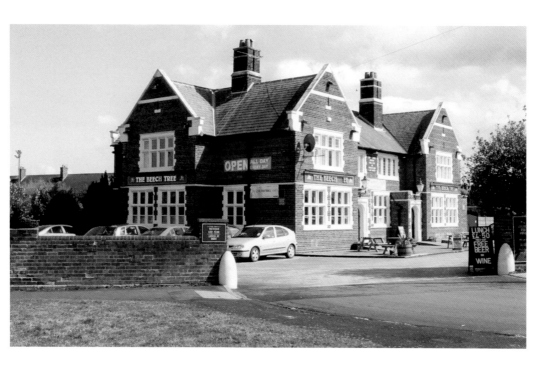

The Beech Tree Public House, Barnton, 1939 and 2007

The new photograph is dated 2007 as the pub was out of action for a while after that. The 1939 photograph was taken when it was new. The original Beech Tree was on the other side of the road, and when the expansion of Barnton was planned before the war a suitably large pub was built. It was opened on the day that war broke out and took over the licence from the Eagle and Child in Northwich High Street. The pub is now up and running again.

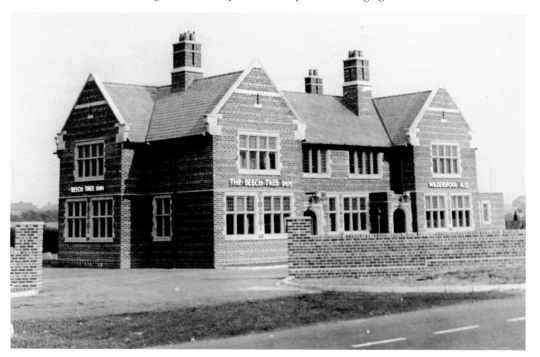

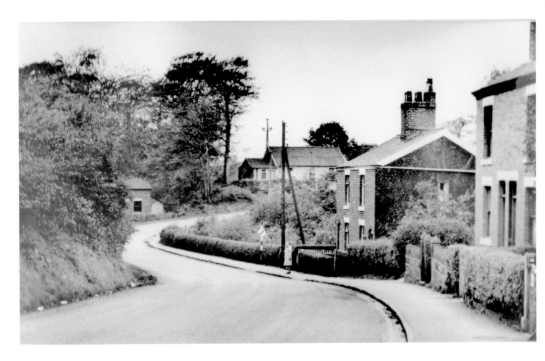

Gunnersclough Barnton, 1934 to 1945 and 2009

The old photograph is dated to 1934 and shows a de-restriction sign just after the woman pedestrian. These signs were erected to show the end of a restricted speed limit such as 30 m.p.h. They were then what the name states, as when passing them speed was not restricted at all until 1965. Gunnersclough or Gunner's Clough is on the outskirts of Barnton towards Anderton and was originally a small hamlet.

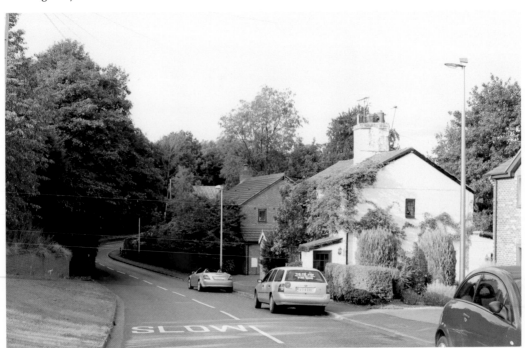

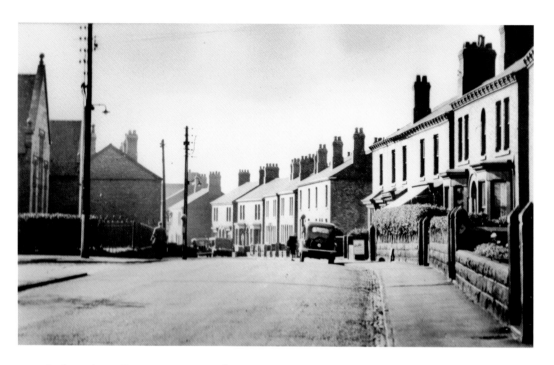

Lydyett Lane Barnton, 1950s and 2009

Pictured is one of the main roads in Barnton, which leads down to Gunnersclough, looking back towards the Townfield Lane junction. The large building on the left in the old photograph has been replaced by a Co-op store in the new. This building was the Brunner School built in 1895. In 1964 it was converted into a village hall, and in 2005 it was demolished when the new Memorial Hall was opened in Townfield Lane.

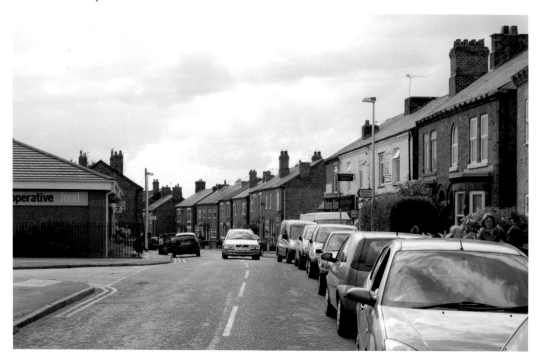

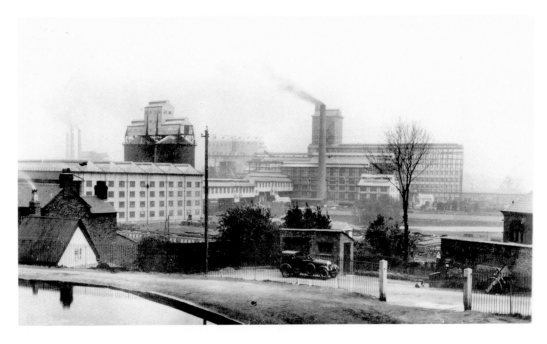

Barnton Hill and ICI, 1920s and 2009

Looking across from the bend above the canal on Barnton Hill we see the ICI works in the distance. This would be Wallerscote works with Winnington works on the far left. The bullnosed Morris in the foreground would appear to have a van rear — quite unusual! The canal can be seen in the left corner as it meanders around the side of the hill, boats here have either just left or are about to enter Barnton Tunnel.

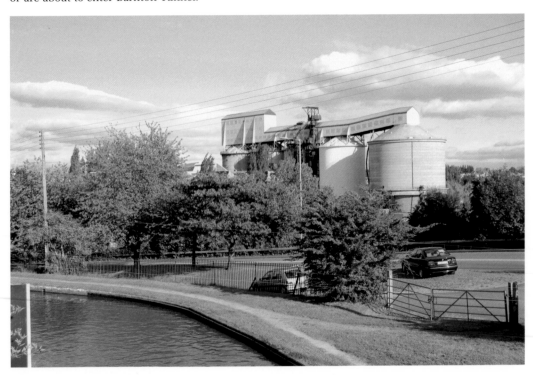

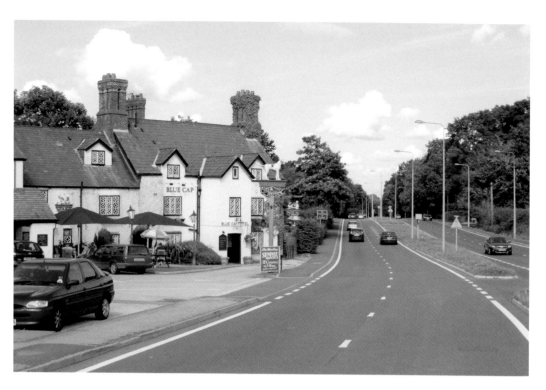

Blue Cap, 2009 and 1890 to 1900

The ancient road from Chester to Manchester once carried the mail coaches that travelled between the two cities and onwards. Hotels were used as staging posts for this traffic and an important one was the Sandiway Head Inn. This famous old inn, which stood on the foundations of an even earlier one, was later to have its name changed to the Blue Cap.

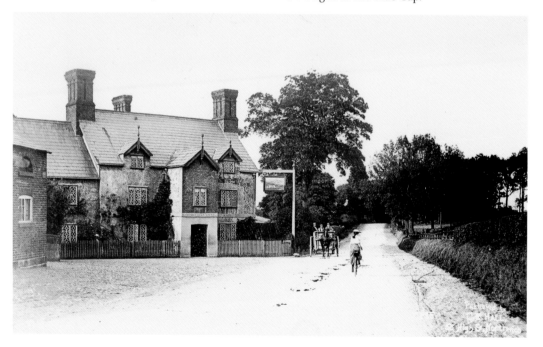

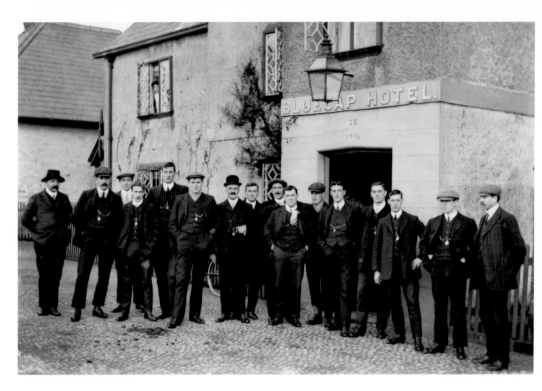

Blue Cap, Manchester United, 1908 to 1909 Season and 2009
Such a prominent public house on a main road is sure to have celebrities through its doors, even a hundred years ago. In this case, the Manchester United team from the 1908-1909 season. The team stood at number thirteen in the old Division One; Newcastle United was number one. How things change!

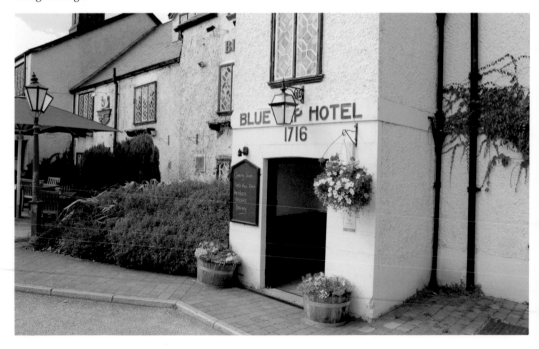

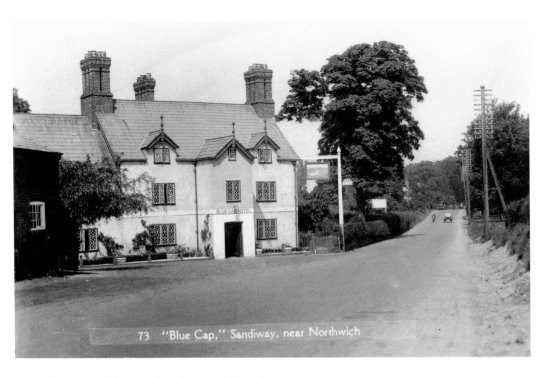

73 "Blue Cap," Sandiway, near Northwich

Blue Cap with Hounds, 1895, and Blue Cap, 1920s

For centuries the Blue Cap Hotel was the starting point for hunt meetings, as can be seen from the old photograph. The second photograph was taken in the 1920s. The name comes from a foxhound called Blue Cap whose owner was challenged to race him. The challenge was accepted and in the subsequent race at Newmarket, with a purse of 500 guineas, Blue Cap came first and his daughter, Wanton, second, winning 400 guineas and 100 guineas respectively; after that the dog was a legend.

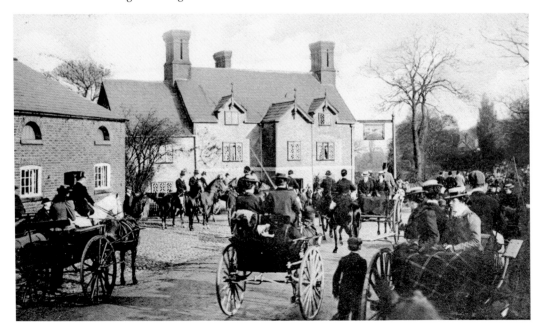

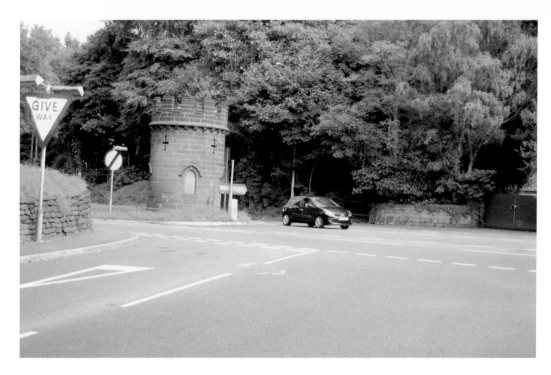

The Round Tower, 2009 and 1910
This tower, built in the early nineteenth century, is now a well-known landmark sitting astride the busy A556; it was once the gate house to a large manor via the later mentioned Monkey Lodge. The house was built from the remains of Vale Royal Abbey for the influential Cholmondeleys, later Baron's Delamere. In 2002 this tower was completely refurbished after a campaign by local people. Until the 1920s it was actually a residence, the last tenants being Hughie Preston and his wife.

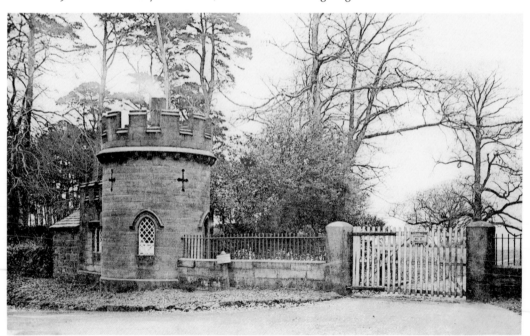

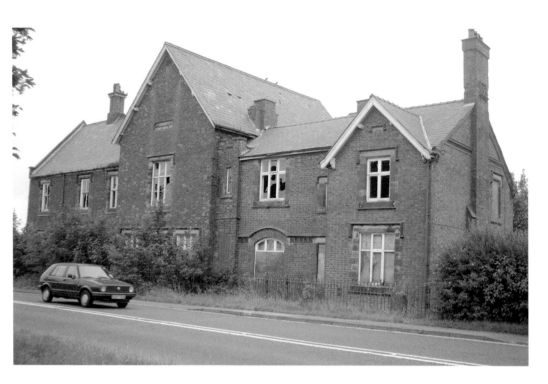

Oakmere Police Station, 2004 and 2009

Not such a gap between then and now here but I believe that this building deserves a place in the book. It was built as a police station and courthouse to take over from the nearby Vale Royal Abbey Arms pub. Prior to its building in the nineteenth century the court was held in the pub and felons detained in the cellar. It went on to be the divisional headquarters for Eddisbury Police Division and stables were built at the rear for the superintendent's horse and trap. Its last duties were as Oakmere Magistrates Court and, despite an appeal to save it, the building has been empty and deteriorating since the 1980s.

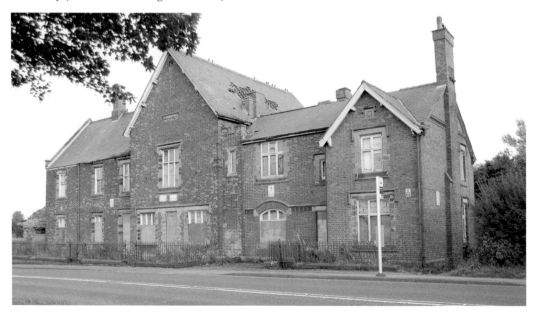

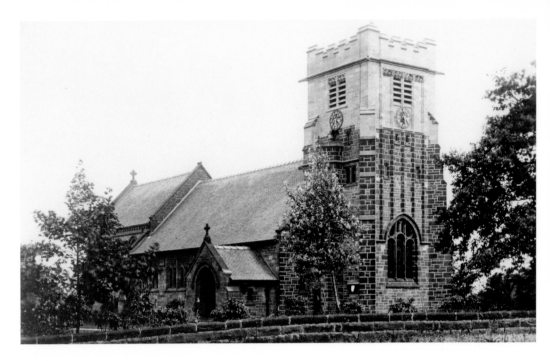

Sandiway Church in Around 1910 and 2009

St John the Evangelist's church was designed by the famous Sandiway architect John Douglas who also donated the land, and it was built between 1902 and 1903. The church was originally built without a tower but this was added in 1911. This can be seen in the old photograph when the newly completed tower can be seen as a different colour to the rest. The sandstone has weathered well in the 2009 photo.

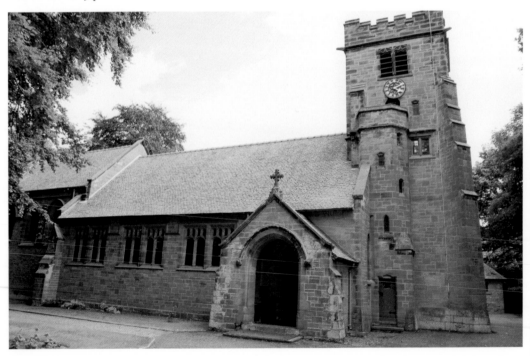

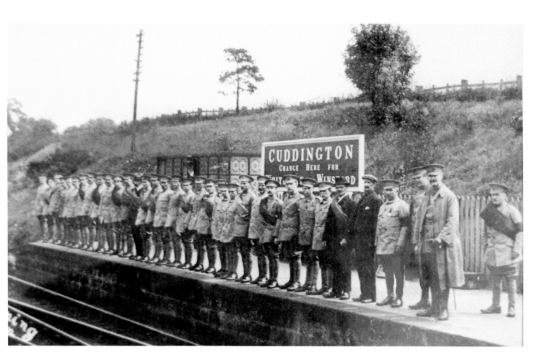

Cuddington Station, 1915 and 25 September 2009

I wonder how many of the soldiers in the old photograph returned? The likelihood is, not very many as they were on the way to the mincing machine that was the First World War. It is quite likely that the soldiers were the Sandiway Local Defence Volunteers, one of the Pal's Brigades comprising local men and estate workers at Delamere. Formations like this made the losses even harder to bear at home when the cream of a town or village would face slaughter together. The station sign advises 'Change here for Whitegate and Winsford'.

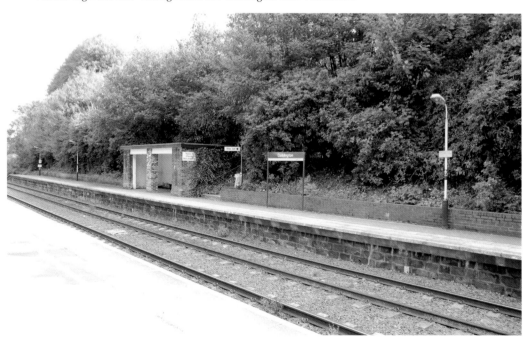

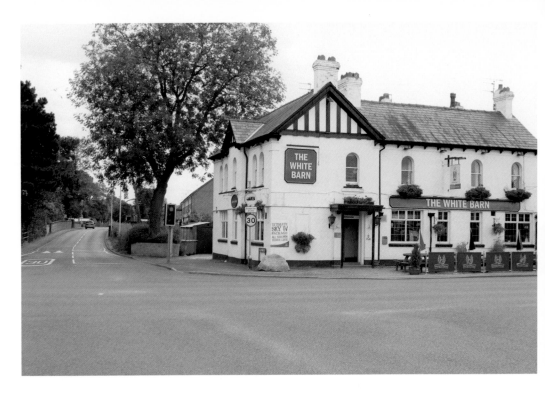

The White Barn, 2009 and 1955

This building dates from 1870, an earlier name being the Red Bull. In 1955 nearby Delamere Park still housed Polish refugees from the war and people awaiting re-housing. During the war it was an army camp, one of the Divisions based there was the US 80th, better known as the 'Blue Ridge Division' who trained for and attacked Omaha Beach on D-Day. Oh, what merrymaking went on within those walls!

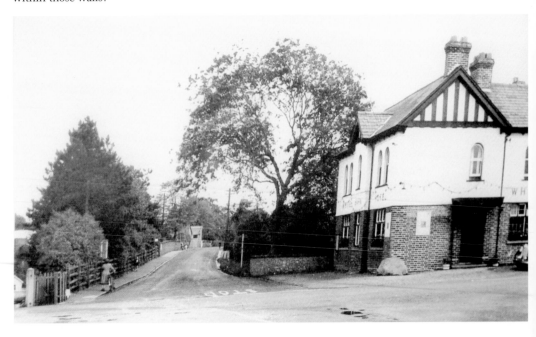

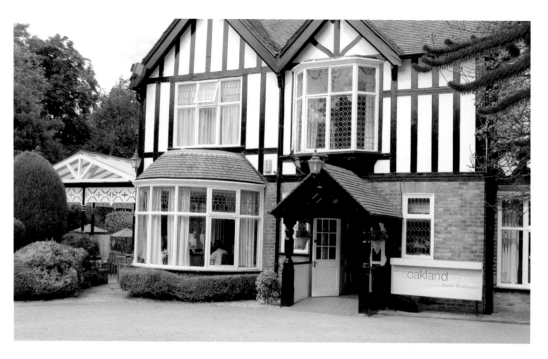

The Oaklands, 1910 and 2009

Not a particularly good old photograph but atmospheric all the same. It shows a pony and trap outside the front of the building. Built in 1904, this prestigious house in Millington Lane between Weaverham and Sandiway was privately owned until 1947 when all of the furniture and fittings were sold to the highest bidder. In 1960 it was converted into a country club, and it is now a pub with function rooms, and hotel set in glorious countryside.

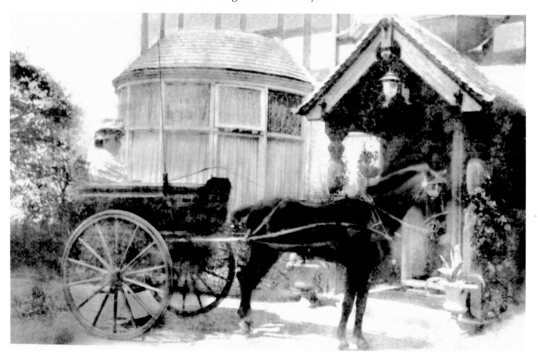

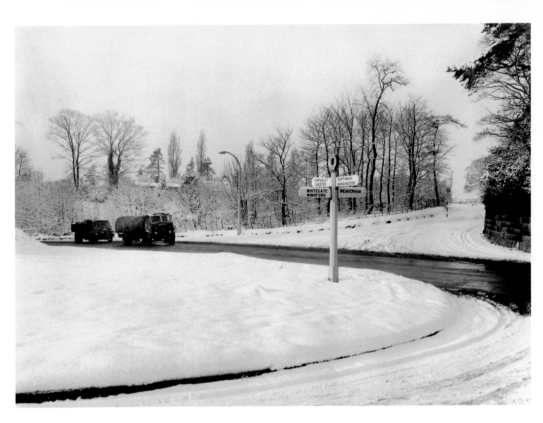

Lorries Leaving Northwich Bypass, 1950s and 2009

These photographs show the junction from the Northwich bypass at the bottom of Speedwell Hill towards Northwich with the Weaverham turn on the left. In the snowy mid-winter scene an Albion flatback lorry leads a more modern Bedford tipper from the dual carriageway during the 1950s.

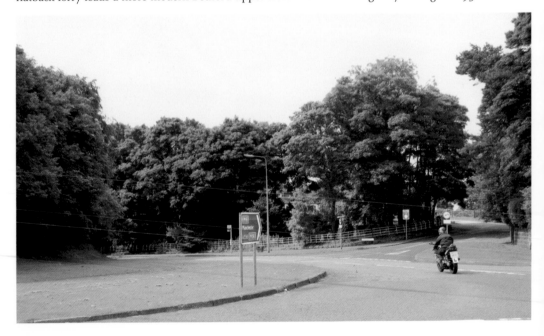

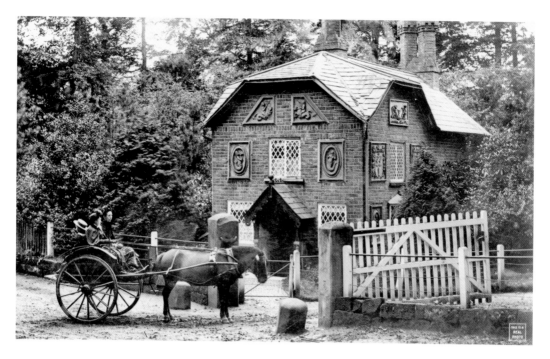

Monkey Lodge, 1890s and 2009

This unusual and clear photograph is of Monkey Lodge at Whitegate. At one time there was a drive from the round tower (see earlier caption) in Sandiway to this house and then into the mansion that had once been Vale Royal Abbey. The name comes from one of the many plaques on the building, one of which is of a monkey. The house is on the Winsford to Northwich road just before Whitegate and, as the 2009 photograph shows, is still there but hidden by foliage.

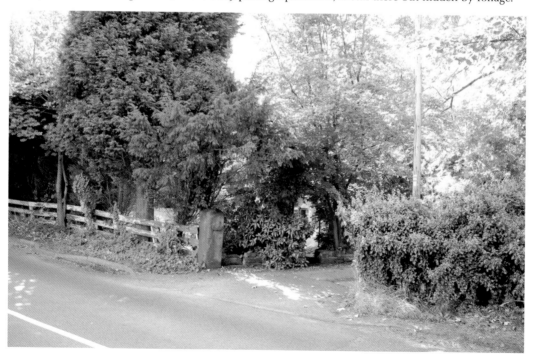

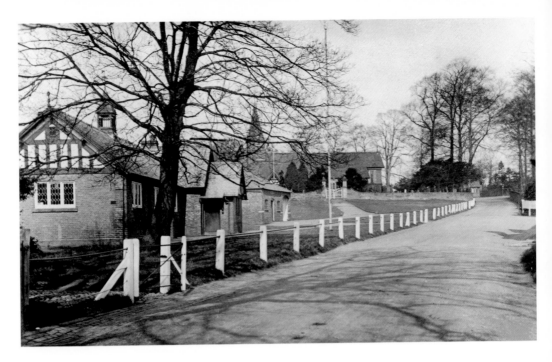

Whitegate Village, 1950s and 2009

In this pleasant village betwixt Winsford and Northwich we look up the main street towards the Church of St Mary. This parish can be traced back to the building of the nearby Vale Royal Abbey. The abbey was named by Edward I *Vallis Regalis* (Vale Royal), hence the name. The monks moved to the Abbey in 1330 and it was completed by 1359. On the Dissolution of the Monasteries St Marys became Whitegate parish church. The present building dates from the nineteenth century and was designed by John Douglas of Sandiway.

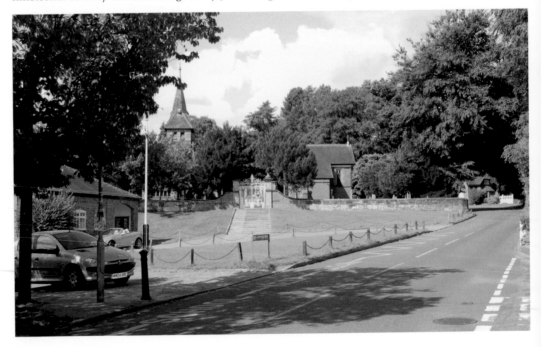

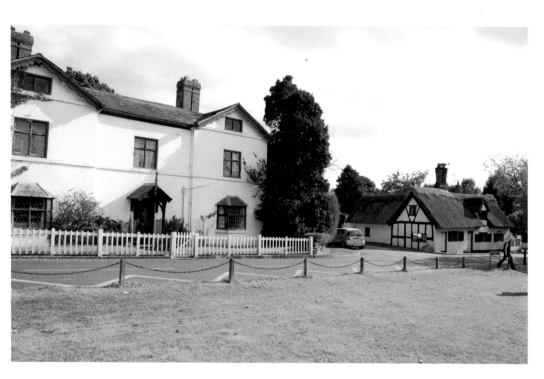

Whitegate Cottage, 2009 and Between 1890 and 1905
This late seventeenth-century cottage is known as Whitegate Cottage, and on the other side of the road can be seen Whitegate House which first came to note as a public house in 1841, it was The Rifleman, named after the formation of The Rifle Brigade in 1800. In 1870, on the orders of the Dowager Lady Delamere who was upset by the behaviour of the locals, especially on a Sunday, the pub was ordered shut and became the home of the estate agent.

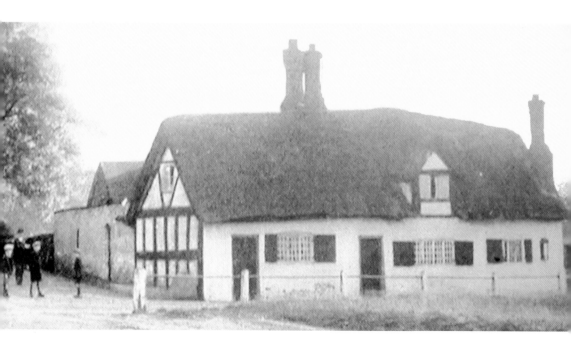

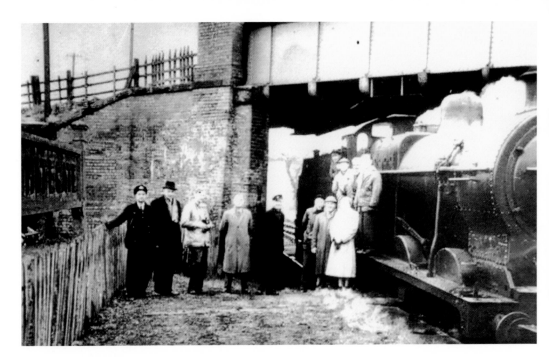

Whitegate Last Train, 1967 and 25 September 2009

Immediately to the west of Cuddington station a single-track branch line was built by the Cheshire Lines Committee to a station called Winsford and Over with an intermediate station at Whitegate. This line was never a success for passenger trains, but as well as the terminus the line crossed New Road Winsford to serve the many salt mines. This old photograph was taken as the last train stopped at Whitegate station, the branch closed on the 6 June 1967 after which the track was lifted.

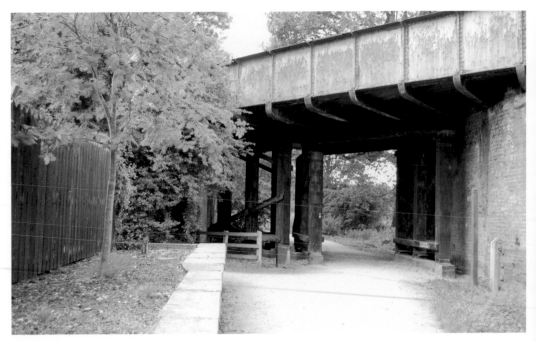

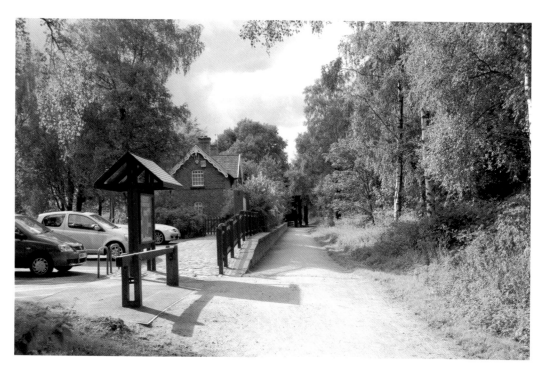

Whitegate Station, 1930s to 1940s and 2009

An interesting view of the station and bridge in days when there would be at most about six trains per day calling at the station. The staff, as can be seen in the photo, would have had plenty of time to tend the gardens on the right. The grounded coach body is a CLC four-wheeled third-class saloon of 1874 to 1876. The track bed is now the Whitegate Way from Winsford to Sandiway and the station a picnic area.

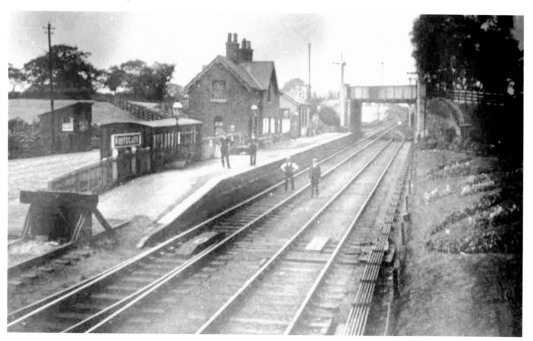

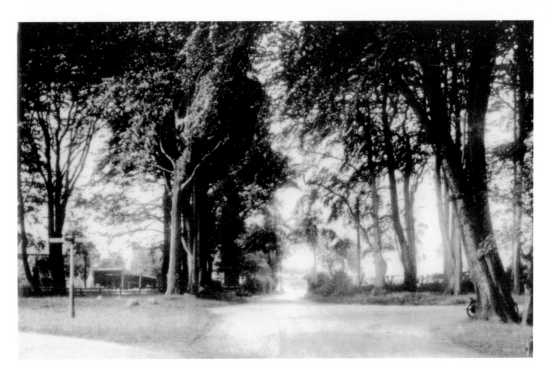

The Beeches Whitegate, 1910 to 1920 and 2009

This crossroads on the road from Winsford to Sandiway has always been a picturesque and shaded area. The large house on the left is called The Beeches and was the childhood home of Ellen Marion Irene Boyd from 1907 to 1977. Although confined to a wheelchair she became a noted painter and author. The photographer's motorcycle can be seen partly hidden behind a tree on the right in the old photo.

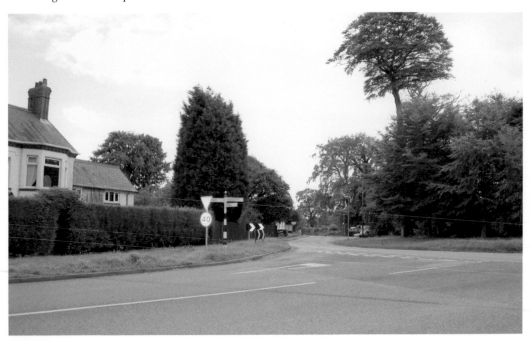

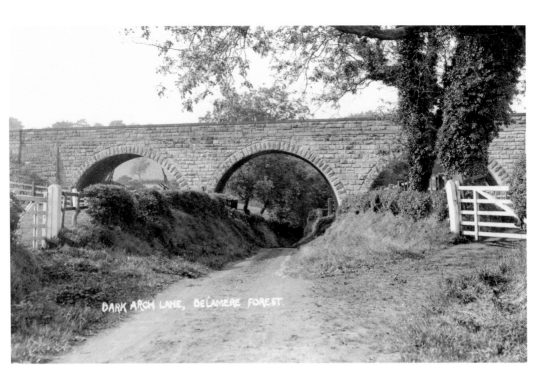

Dark Ark Bridge in the Early 1900s and 2009

Now we venture into Delamere Forest, and on the road to Manley is the railway bridge across Dark Ark Lane (the name on the old photograph is incorrect). This bridge carries the line from Manchester to Chester and is a good example of the build quality in the early days of the railway when labour was cheap.

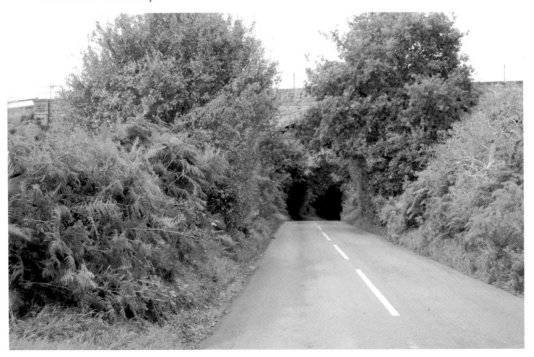

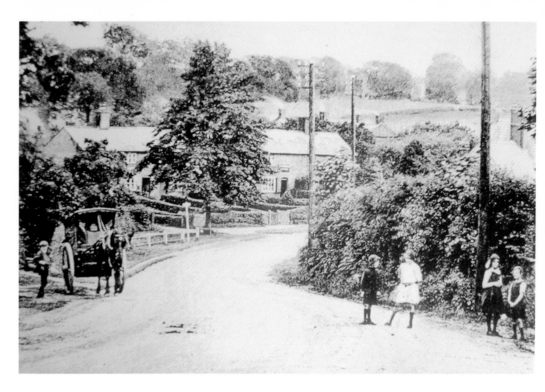

Cotebrook Downhill, 1895 and 2009

Back now on what is the A49 Tarporley Road and down the gradient through the hamlet of Cotebrook. Little has changed over the years other than the vast increase in traffic. Those children would not have been able to stand where they are. In fact, taking the new photograph meant risking my life on this fast and busy arterial road!

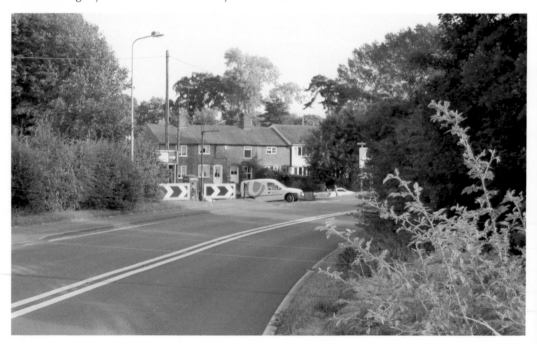

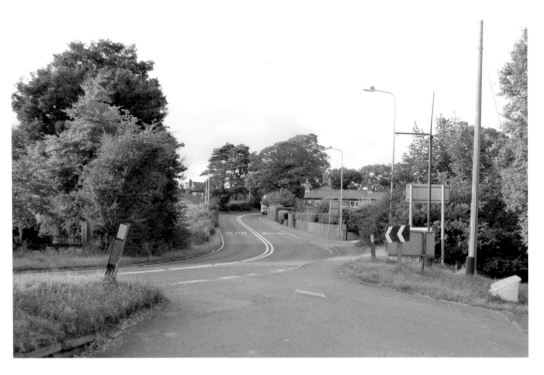

Cotebrook Uphill, 1895 and 2009

As in the previous pair of images, traffic has greatly increased in this area — just look at the huge articulated lorry coming into view in the 2009 shot!

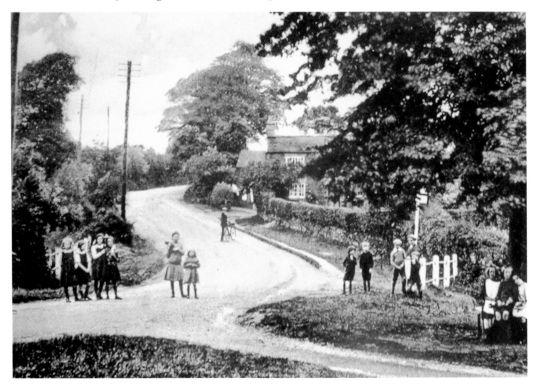

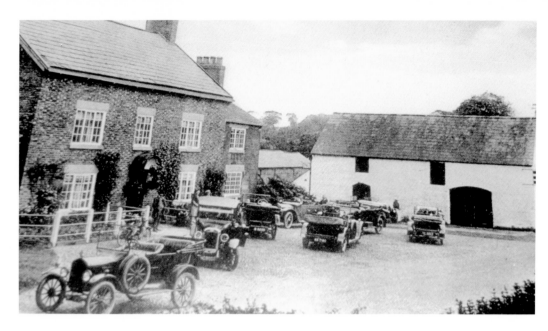

Alvanley Arms, 2009 and 1910 to 1925

Not the best of old photographs but it provides an interesting look at the forecourt of the Alvanley Arms at Cotebrook. Landlords at the pub are listed from 1666 to the present day. Until 1888 it was called the Ardern Arms, which is one of the family names of the Earl of Haddington, one time owner. The inset shows the building date over the door.

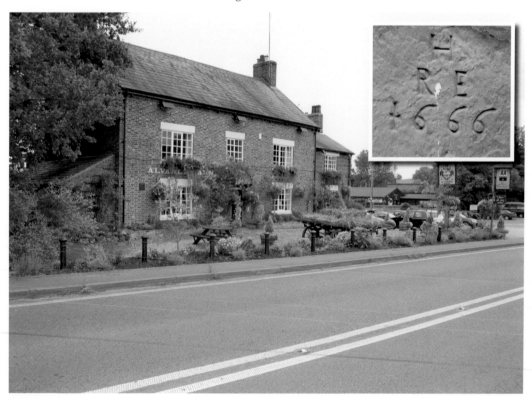

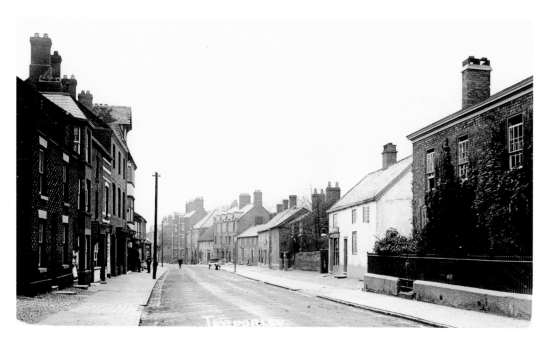

Tarporley, 1900 and 2009

A quick look at the ancient town of Tarporley — which may be the subject of another Through Time book — this photograph looks down the main street. Most of the buildings are hidden behind the trees and there is considerably more traffic. This was once a main trunk road but has now been bypassed, albeit that the traffic is still heavy!

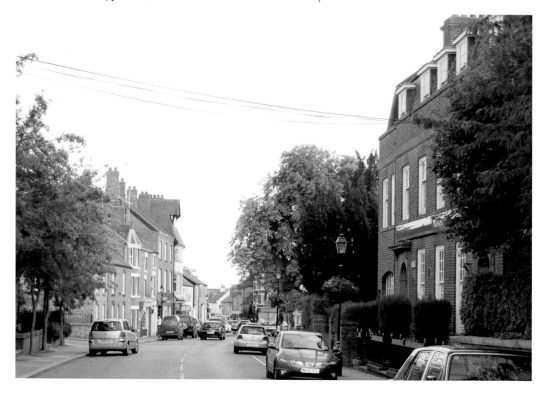

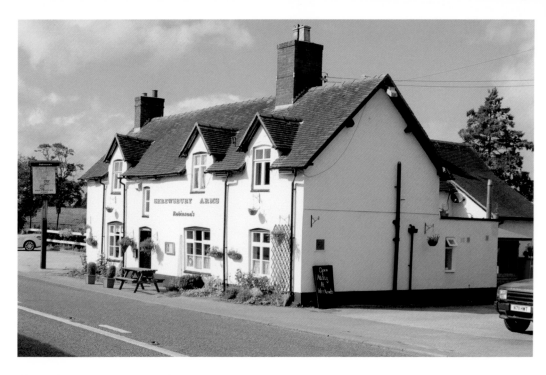

Shrewsbury Arms, 2009 and 1900

As with the last old photograph, we use this with an apology for the quality. The scene is the Shrewsbury Arms, another pub owned originally by the Earl of Shrewsbury, after whom it is named. Licensees go back to 1872 but it is believed that prior to that it was the Bears Paw, but there are no licensees listed between 1834 and 1872. At one time there was a racecourse at the pub's rear.

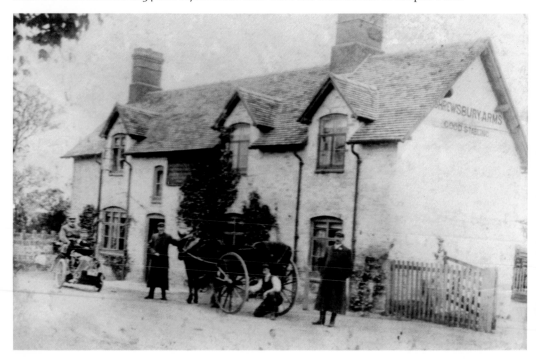

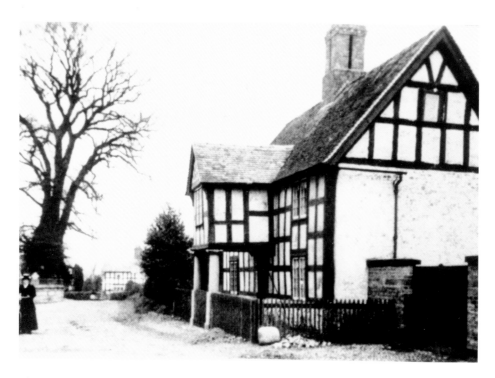

Church Minshull, 1895 to 1910 and 2009

The last of our villages and we are on the road from Winsford to Nantwich in the pretty village of Church Minshull. Black and white buildings predominate and the photographs show Church Farm, which is opposite St Bartholomew's church. The building has a 'magpie porch' and at one time was the vicarage. It is believed that it was once the home of Elizabeth Minshull, the third wife of the poet John Milton. They married on 24 February 1663 and he died in 1674. She was thirty years his junior and lived to the age of eighty-nine.

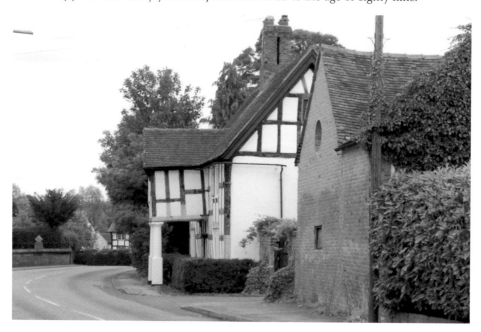

Acknowledgements

I would like to thank the Cheshire West and Chester Council and Matt Wheeler from the Salt Museum for permitting me to use photographs from their archive. Mike Hornby of the Weaverham History Society and Peter Craven of the Northwich Heritage Society for both the loan of photographs and their excellent counsel. I would also like to thank Barrie Johnson and David Michael Callis for information and photographs of their beautiful cottages and Jim Talbot, Gerry Mort, Bob Curzon, Flo Such and Susan Merrill for their loan of photographs and/or advice.

The managers of the Spinner and Burgamot, the Red Lion of Little Budworth, the Shrewsbury Arms, the Coachman, the Beech Tree and the Alvanley Arms public houses for allowing me to borrow photographs from their walls! I would also like to thank Sarah, Sue and the staff at Amberley.

Finally I would like to thank my wife Rose for her unlimited patience during the lengthy compilation of this book, not to mention her willingness to accompany me on expeditions into deepest Mid Cheshire to take the modern photographs.